EXPOSÉ

EXPOSÉ

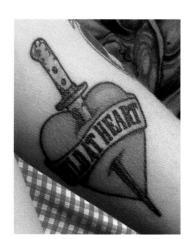

THE ART OF TATTOO

TIM O'SULLIVAN

A Citadel Press Book
Published by Carol Publishing Group

To the late great Sean Hogan

A Citadel Press Book
Published by arrangement with Robinson Publishing Ltd, London

Citadel Press is a registered trademark of Carol Communications, Inc.
Editorial Offices: 600 Madison Avenue, New York, N.Y. 10022
Sales and Distribution Offices: 120 Enterprise Avenue, Secaucus, N.J. 07094
Queries regarding rights and permissions should be addressed to:
Carol Publishing Group, 600 Madison Avenue, New York, N.Y. 10022

Carol Publishing Group books are available at special discounts for bulk purchases, for sales promotions, fund-raising, or educational purposes. Special editions can be created to specifications. For details contact: Special Sales Department, Carol Publishing Group, 120 Enterprise Avenue, Secaucus, N.J. 07094

ISBN 0-8065-1430-2

Designed by Jonathan Newdick

Printed by Arnoldo Mondadori, Italy

10 9 8 7 6 5 4 3 2 1

PHOTOGRAPHER'S PREFACE

In compiling this book my primary interest was to show how people from all walks of life become fascinated in the age-old tradition of decorating their bodies. Sadly, today they are often unjustly regarded as the outsiders or weirdos of society. I found myself at Expo 91, the biggest tattoo convention in the world, amongst a myriad of personalities bearing bright and wonderful works of art on their skins. Symbols ranging from Pop Art to the occult worn as a direct statement of their identities, moulding their personal relationships with the world.

In working with these people I found them to be ordinary gentle individuals who lead normal lives – vicars, butchers and city gents – except they are mobile works of art. Rubbing shoulders with them I felt strangely under-dressed in my untattooed body.

When we walk down the street and see the end of a tattoo emerging from a shirt sleeve we can experience our prejudice and suspicion regarding people who have made a permanent statement for life, who risk placing themselves outside normal society. These curators of a mostly hidden art undermine our confidence to perceive the truth in a person. Cover up the tattoos in this book with your hand and you can recognise the faces of ordinary people, the newsagent, the sales rep or the smartly dressed woman sitting next to you on the bus, and realise that we are all part of the same humanity under our skins.

Special thanks are due to Jon Hope, Gavin Burke, Alex Binnie, Mark Roalfe, Andrea Rosenberg, Nick Robinson and Mike Spry.

To me there is nothing uglier than a 'bad' tattoo and nothing more beautiful than a 'good' one. At their worst tattoos represent a disfigurement to the human flesh and, at their best, a living work of art

When I first decided that I needed a tattoo – twenty five years ago – I was unaware of the difference. But, in those days, my needs far outweighed my judgement and taste. And when I say needed, that is exactly the feeling I had. A 'need' to be marked. I've attempted to analyze it since, and being once a professional psychologist I have attributed my 'need' to some form of inherent tribalism, and an effort to establish my identity within the 'tribe'. Why I had this need and others did not, I couldn't say. Put it down to some latent instinct – less latent with me than my college friends – or possibly to too many hours spent watching well-inked rock and roll stars performing at the Boston Garden.

My first attempt at fulfillment took place in New Hampshire. I drove up from Boston – where tattooing was illegal in the late sixties – and stopped at the first shop with 'TATTOO' emblazoned on its window. The proprietor, who greeted me from a supine position on a filthy mattress in the corner of his shop, appeared to be some form of ancient mariner – if the crude anchors and naked ladies adorning his own arms could be interpreted as 'tribal' identification. He was definitely drunk, and apparently suffering some kind of delirium tremors, evidenced by terminally shaking hands, a propensity to mumble incoherent phrases, and flesh-melting halitosis. He demanded to see my ID (proof that I was twenty one), cursed me for not having

any (it was illegal to tattoo anyone under that age), then shouted me out of his premises. A close call . . . And one that set me back dramatically, until I hit middle age and the 'need' reared its head again.

By then, however, I had become sophisticated enough to tell a tattoo artist from a back street 'scratcher'. And my tribe had shifted from the Flower Power brigade to the new order of the 'urban bikers'. Having admired several pieces of art on my Harley-riding friends I decided to celebrate my rediscovery of two-wheeled travel by a visit to the tattooist (at thirty nine there was no longer any danger of being under age).

I agonized over an appropriate design, came up with a Japanese Samurai crest, depicting an abstract rendition of a crane, the eastern bird of long life, then paid a visit to the well known tattoo artist George Bone. A tinge of nerves, a sensation that felt like ten thousand micro bee stings, and fifteen minutes later I was 'inked'. That crane, tattooed in brilliant blue, gave me at least a hundred hours of viewing pleasure in various mirrors. Until I was ready to enlarge my wildlife collection. By then I had seen the work of Ian of Reading.

Ian is a fine artist and his tattoos actually look alive. I started with a Celtic bird wrapping round my forearm and further fulfilled my 'need' with a lion's head, incorporating George Bone's crane, mounted on my right shoulder. My new collection provided hours more of personal viewing pleasure. Like looking at some kind of magic, engraved into my flesh. Even my wife, Lynda – who also professed to a

tattoo 'need' since the sixties – was impressed enough to make the pilgrimage to Reading. Returning with a thorny rose, in muted shades, on her left shoulder.

Since then I have collected books on the 'art of the tattoo', attended exhibitions and conventions and even incorporated tattoos into my own works of fiction. I still think of the tattoo as a form of magic, a talisman that blends with and is given life by the flesh it adorns. Changing with the movement of the body, but always present. A living work of art.

Exposé: The Art Of Tattoo succeeds in displaying this art in a myriad of styles and eccentricities, from the bold 'tribal' pieces to the delicate air-brushed look of the portraiture, from 'body suits' to single patterns: outlined, shaded, and detailed to create works as individual as the personalities and flesh they embellish. The photographs in *Exposé* illustrate an ancient art which has evolved to become a testimony to modern man and his sense of individual identity.

Richard La Plante's novel, *Mantis*, will be released in the United States in May, 1993, and is currently in pre-production as a major motion picture. His latest novel, *Leopard*, which features the Japanese style of tattoo, will be released in the UK in November of this year.

Lynda La Plante is a best selling novelist, screenwriter and the creator of 'Prime Suspect', the award-winning TV drama.

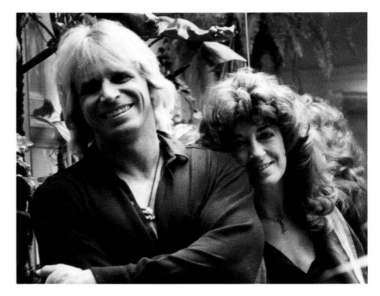

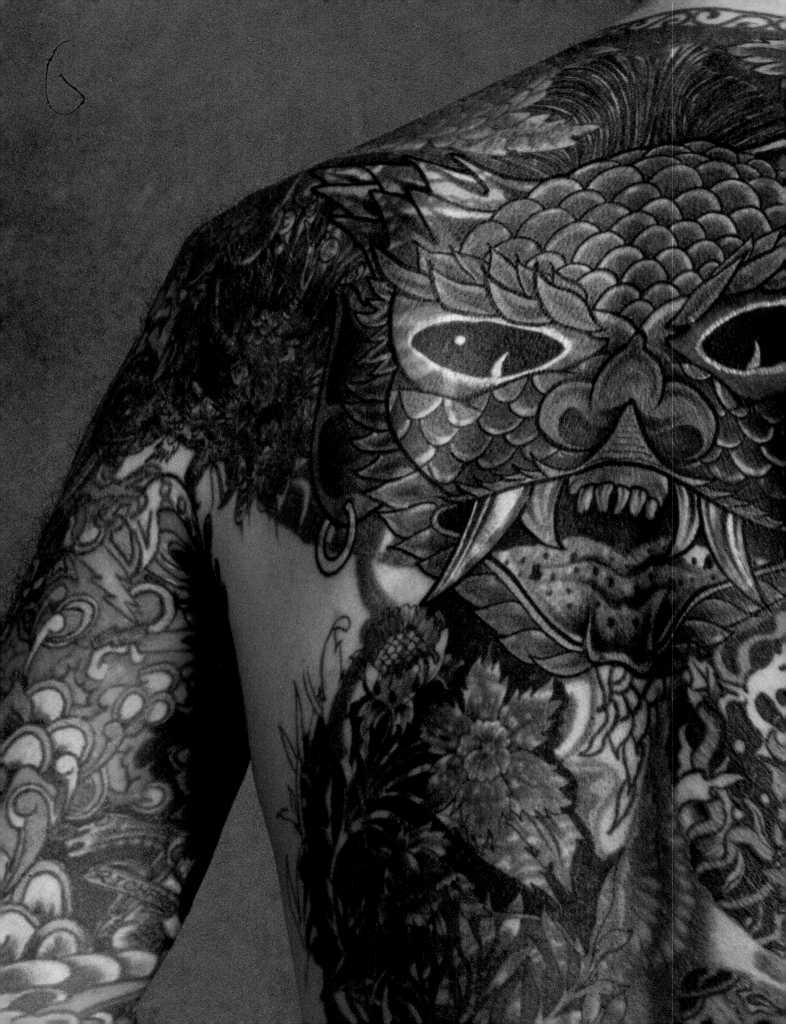

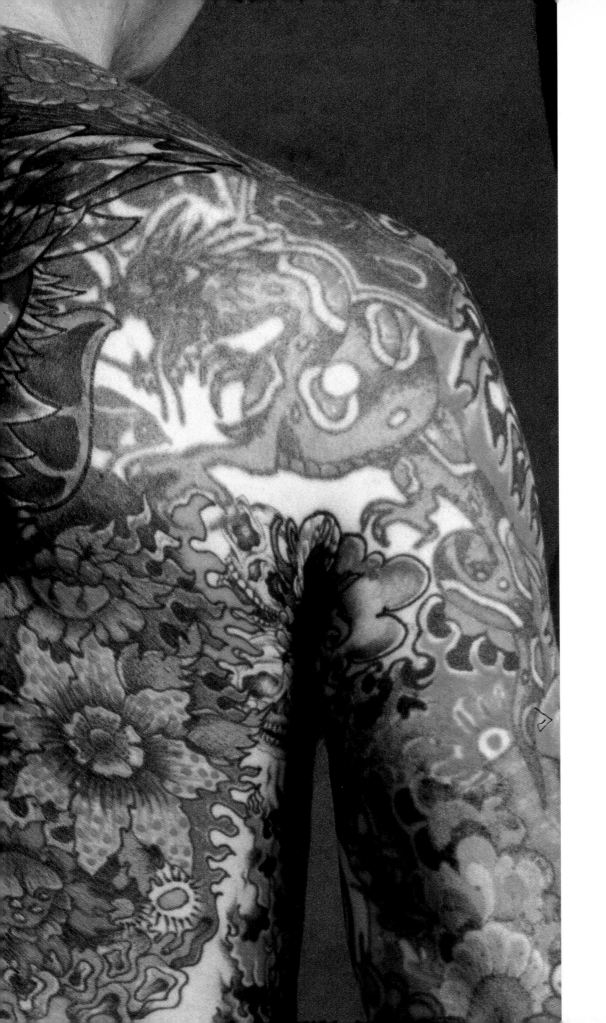

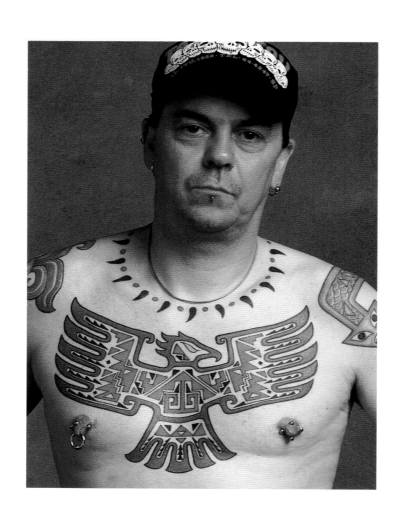

ABOVE *John, motorbike messenger*
OPPOSITE *Annabelle, harbour officer*

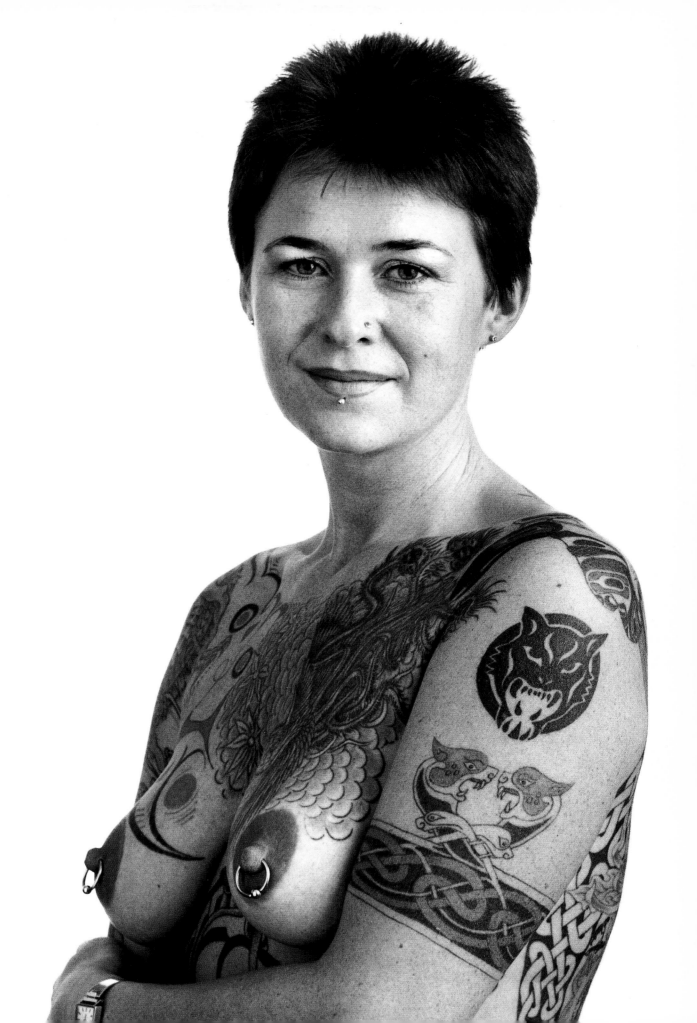

Annabelle,
harbour officer

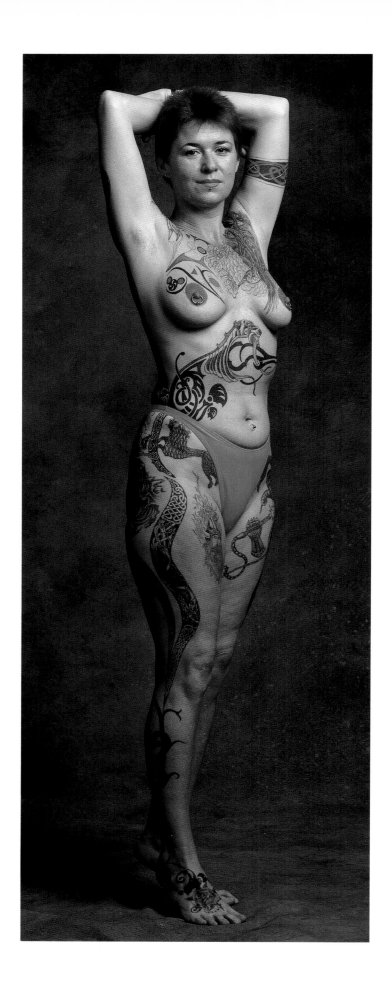

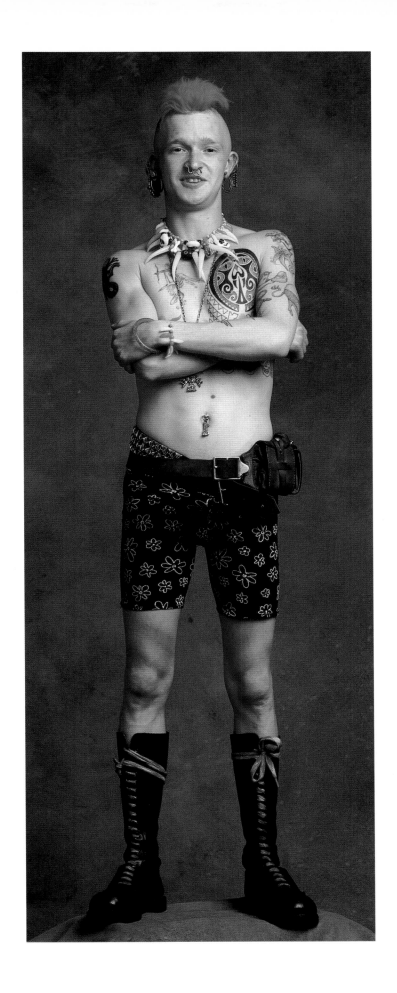

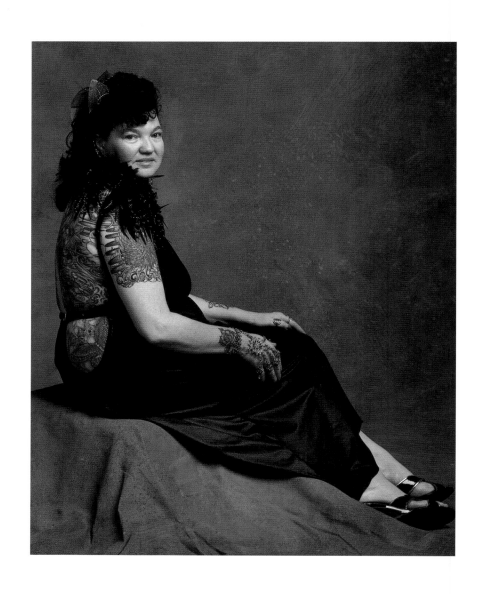

Pauline, magazine editor

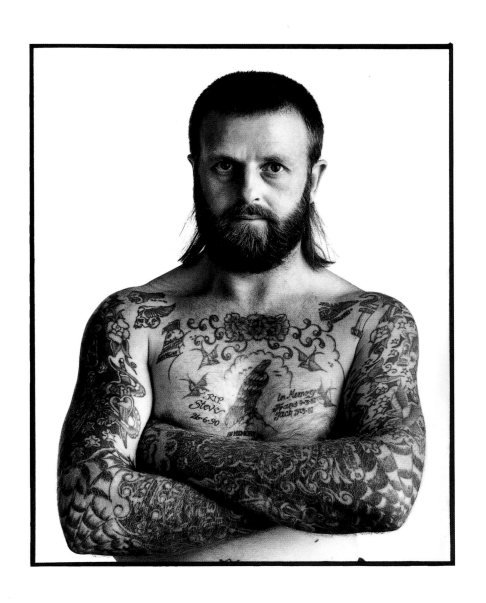

Chesty, tree surgeon

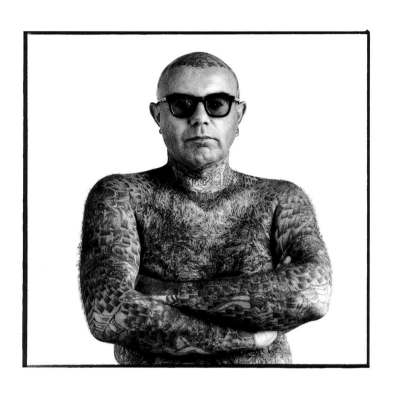

ABOVE AND OPPOSITE *Dave aka Spiderman*

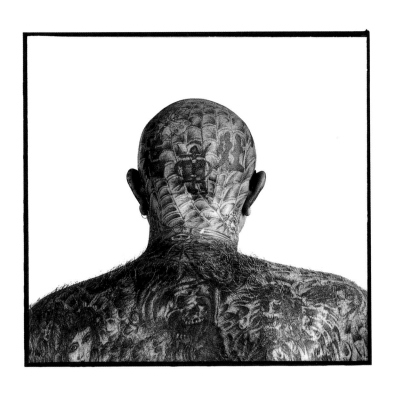

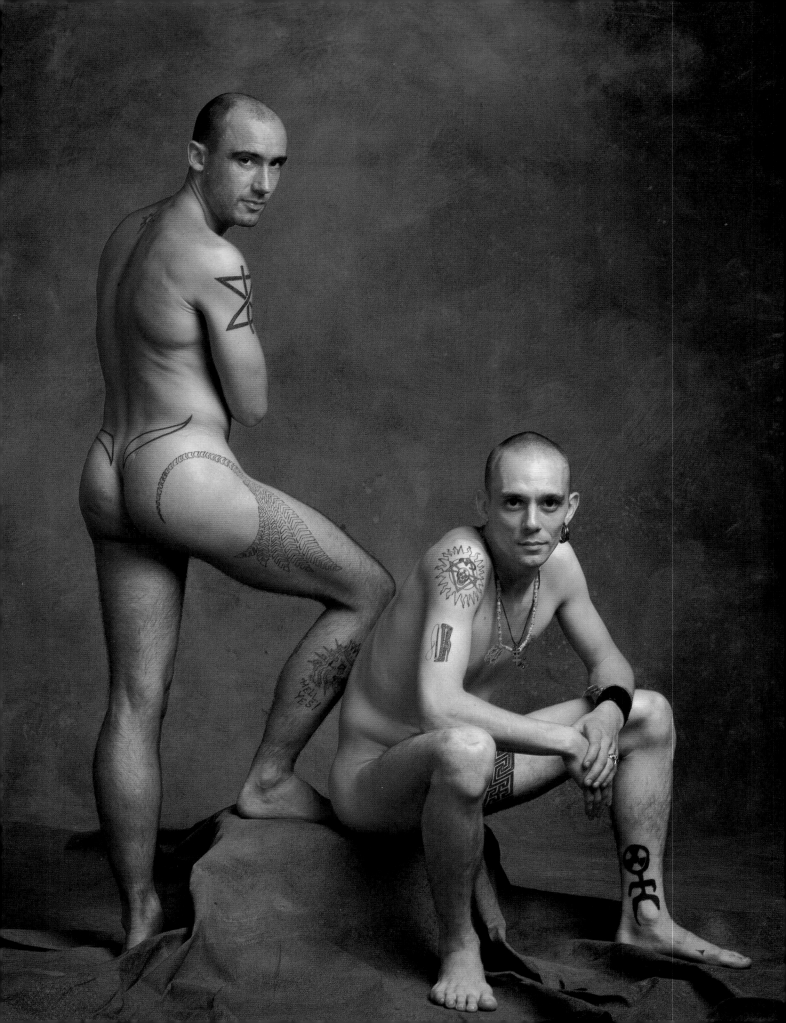

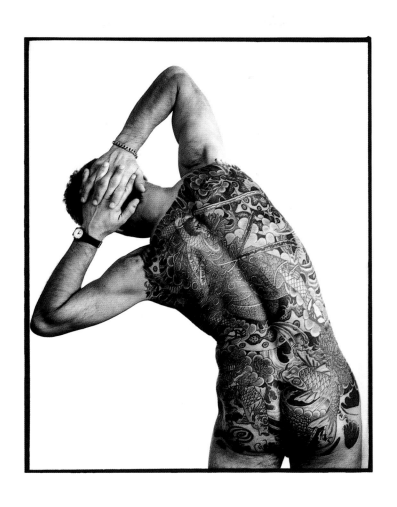

ABOVE *Andrew, clothing salesman*
OPPOSITE *Christopher, and Sean, unemployed*
OVERLEAF *George, retired, and David, scaffolder*

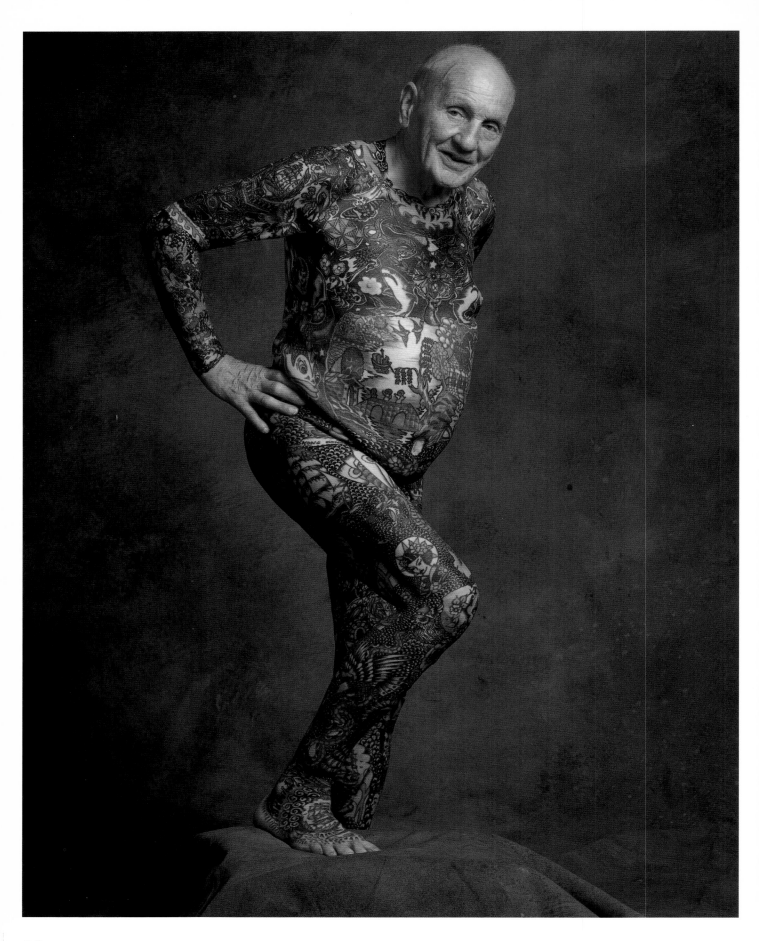

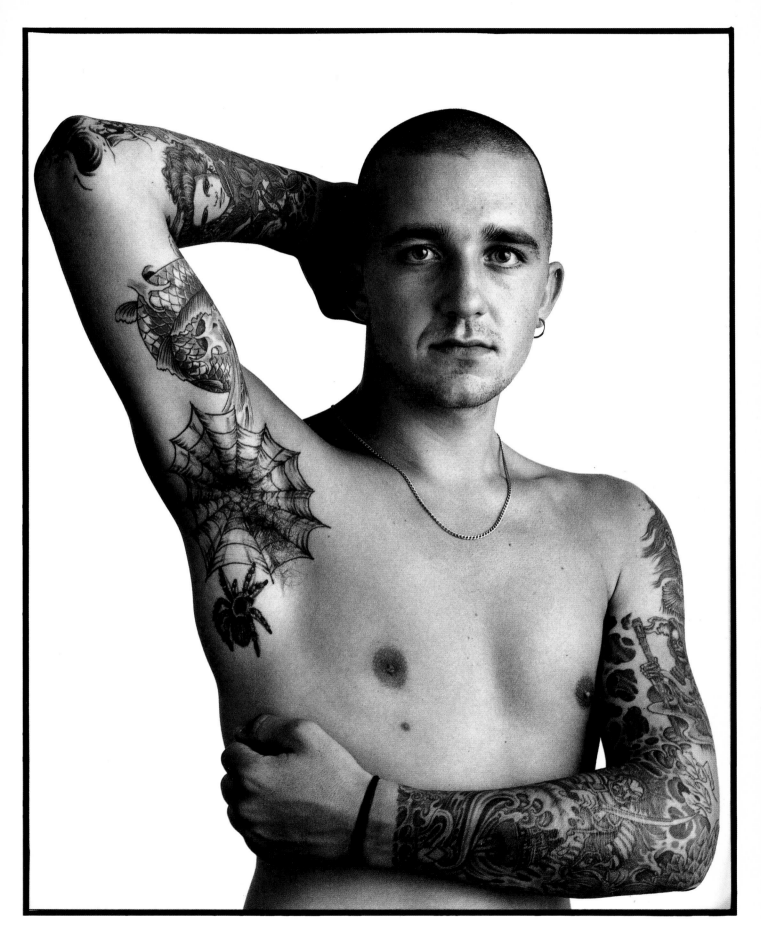

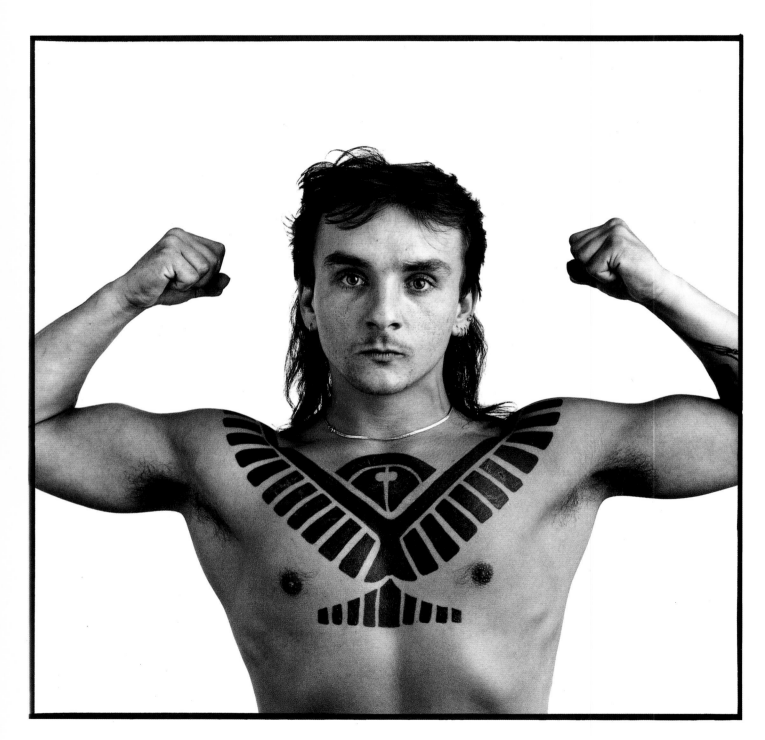

LEFT *Dan, mechanic*
OVERLEAF
Brent, Ian of Reading,
Lal and John, tattoo
artists

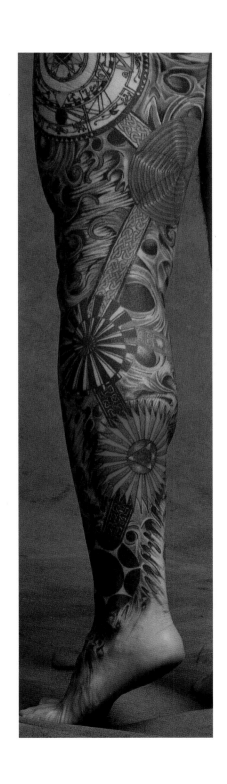

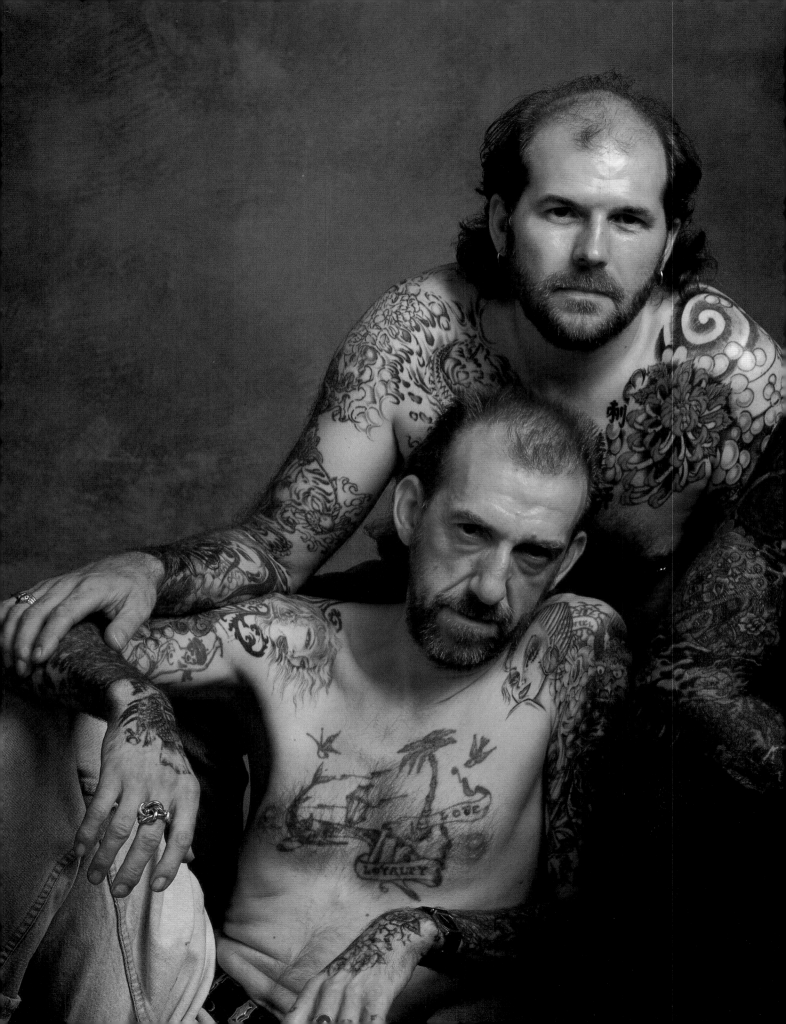

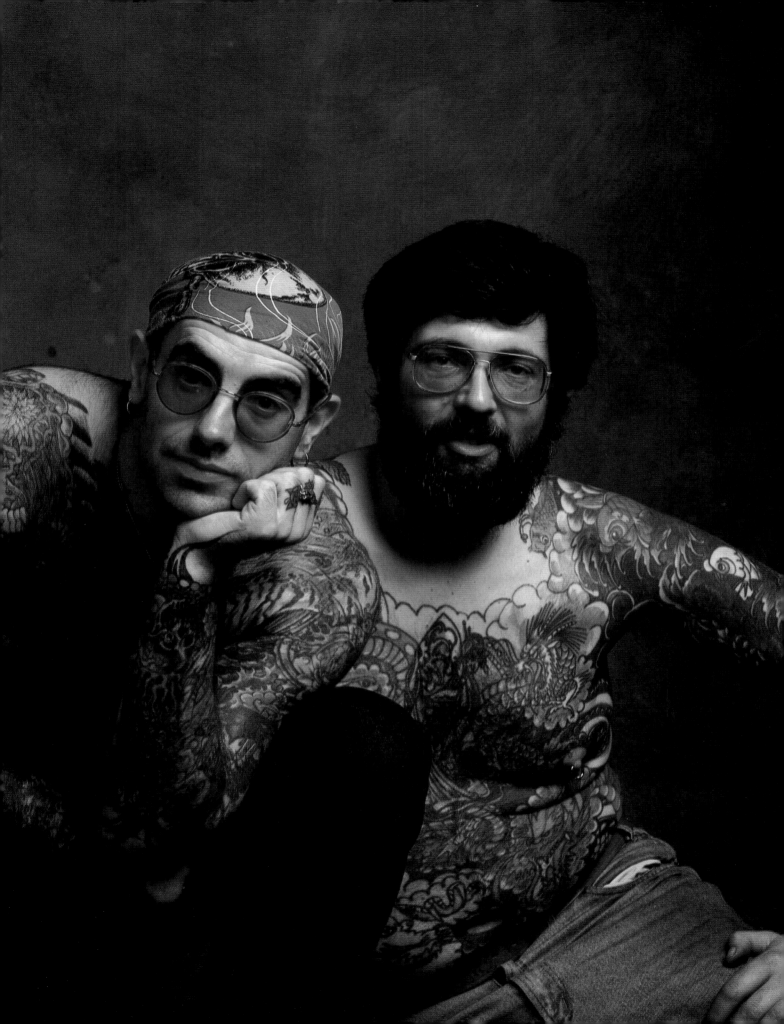

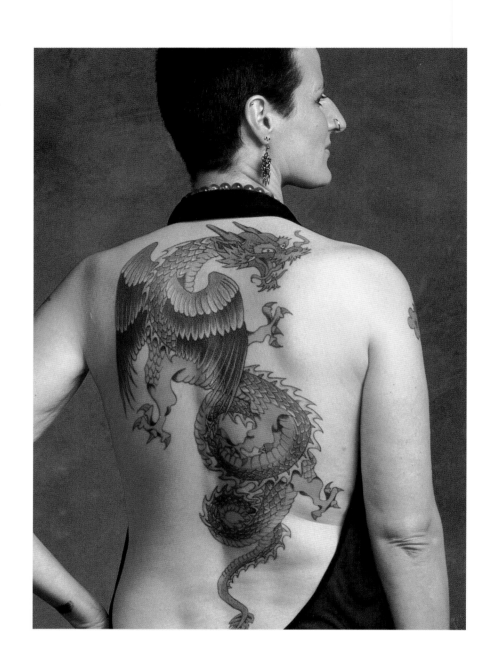

Irene, body piercer and tattoo artist

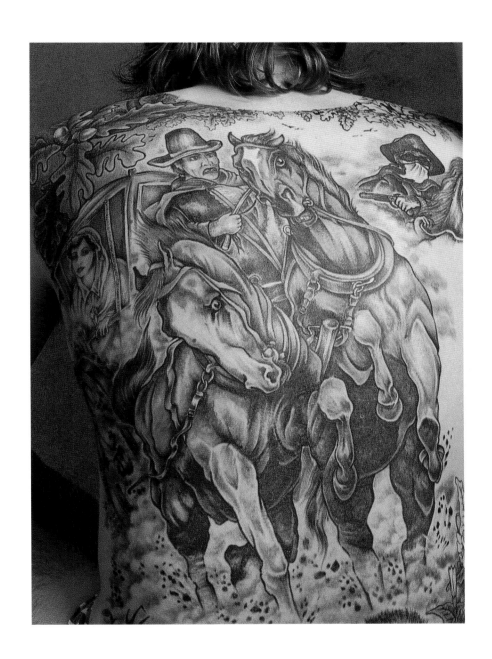

Isabelle, waitress

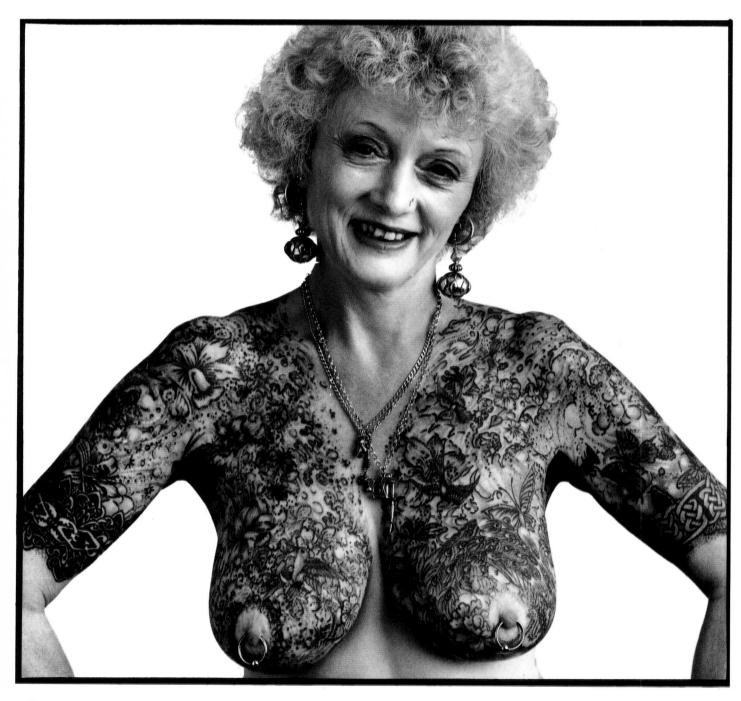

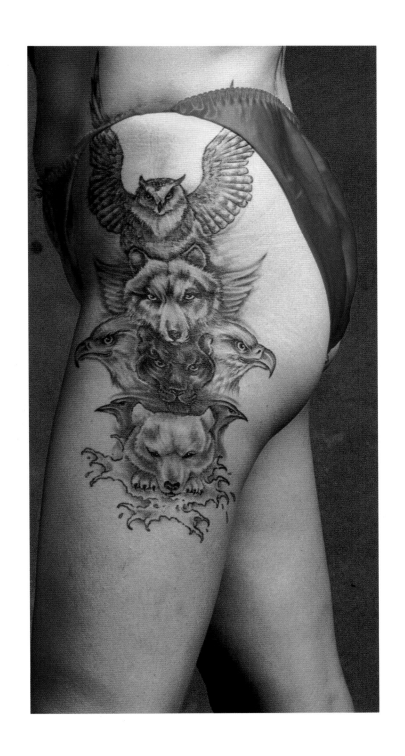

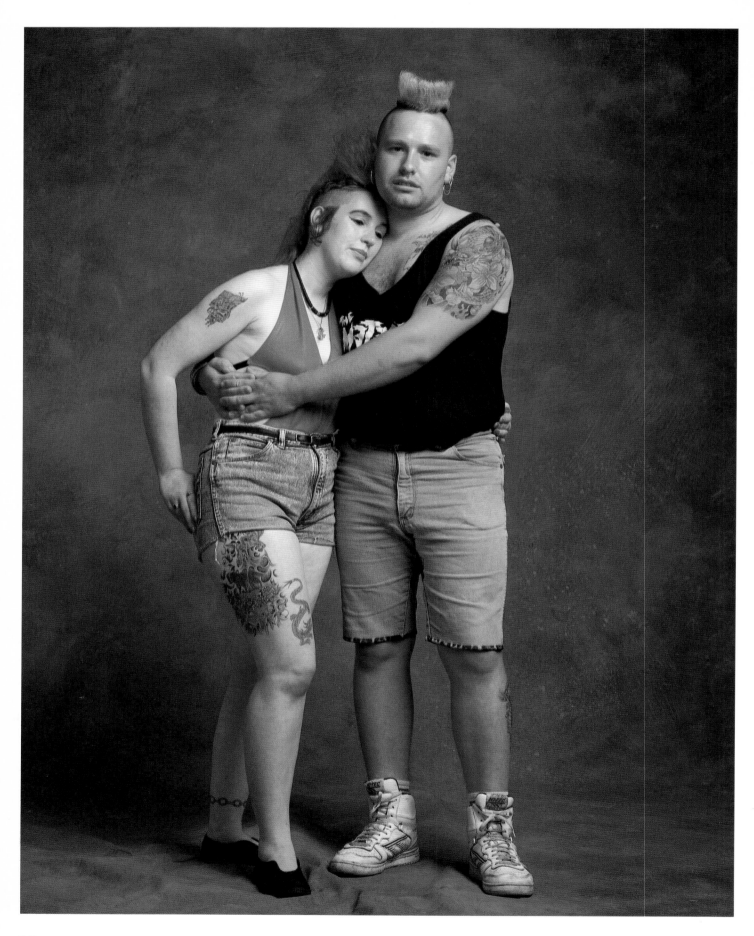

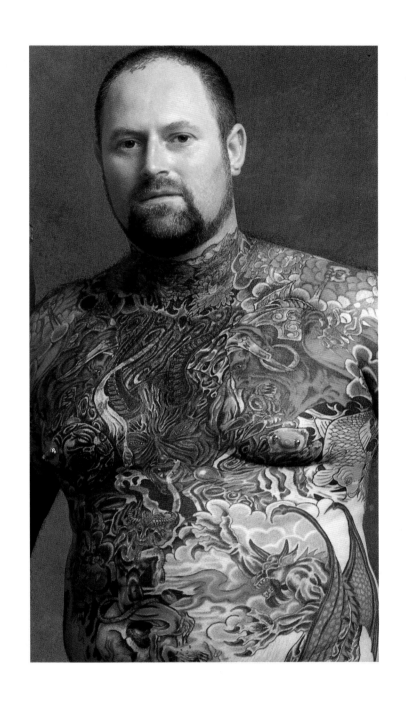

ABOVE *Big Dave, mechanic*
LEFT *Pat and Jo, psychobillies*

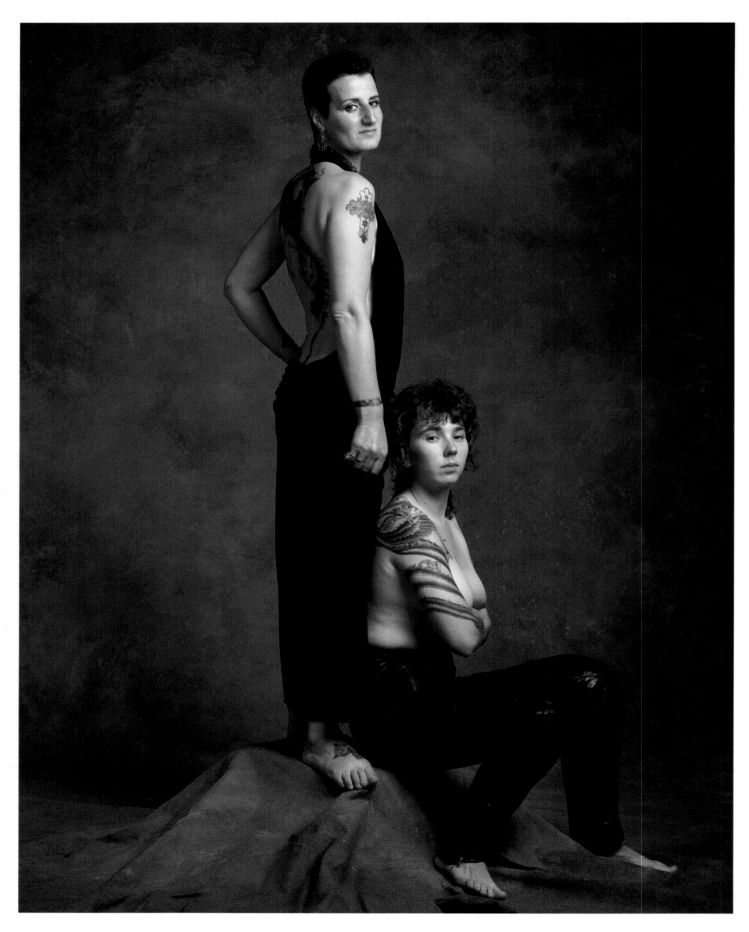

LEFT *Irene, body piercer and tattoo artist, and*
Susanne, rock climber
BELOW *Roger, truck driver, and Tracey, butcher*

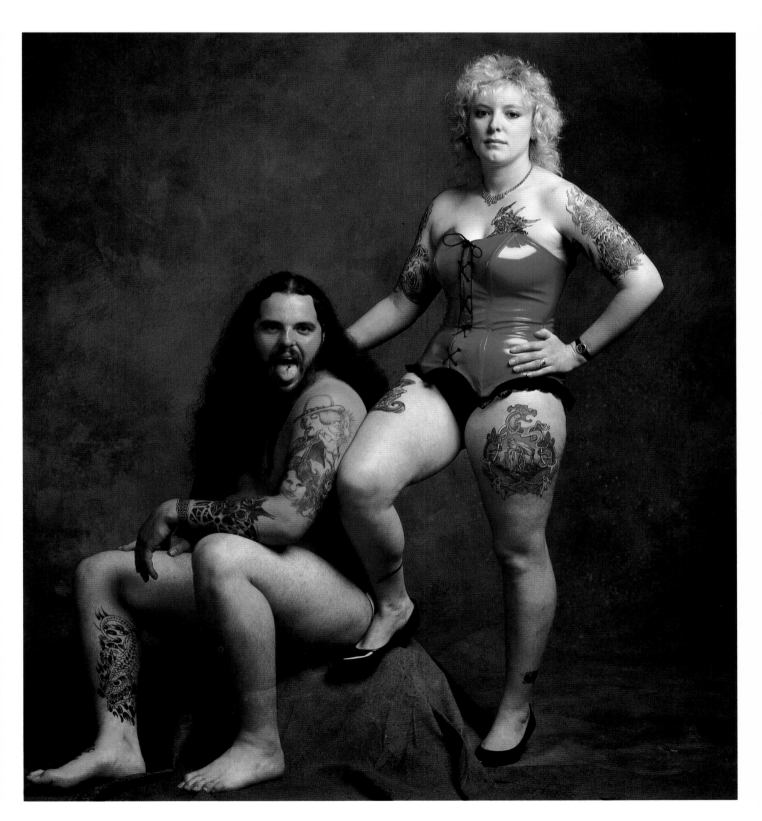

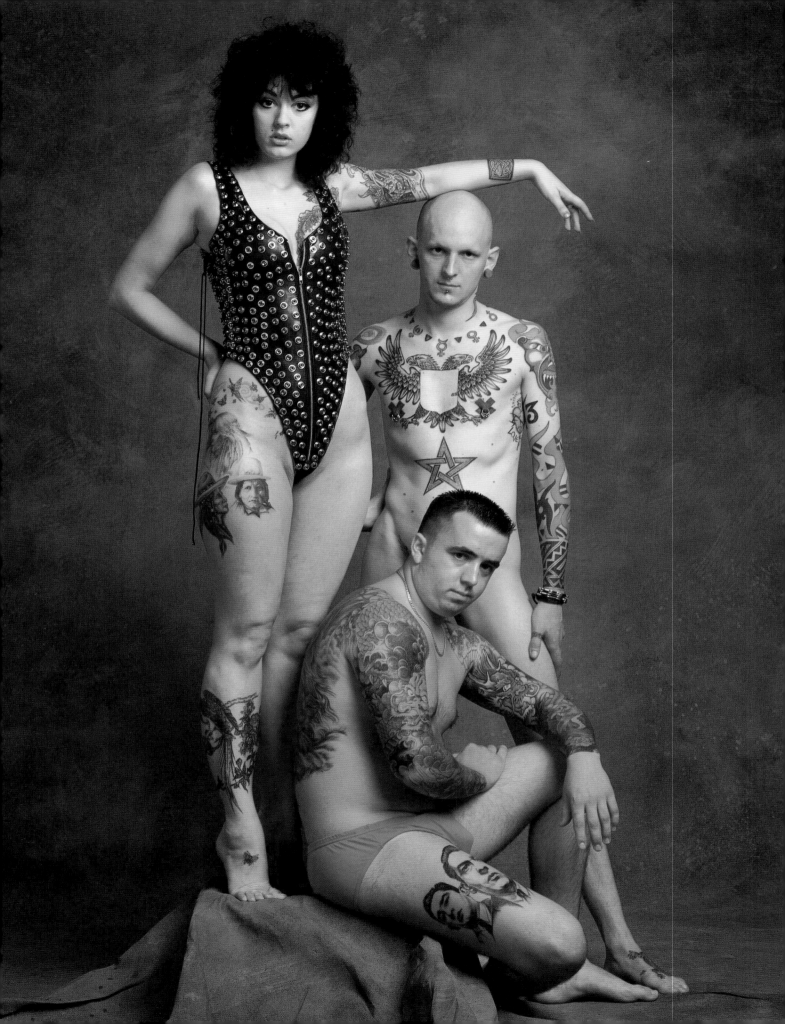

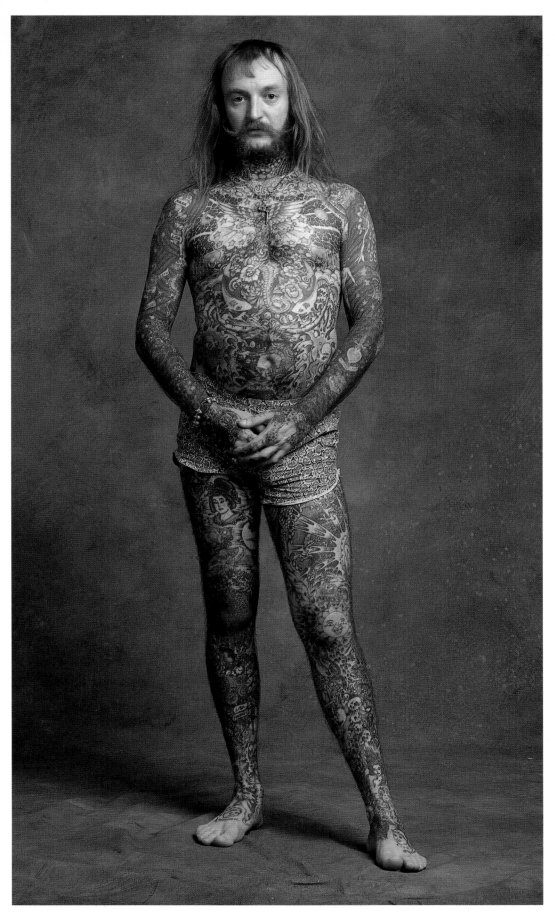

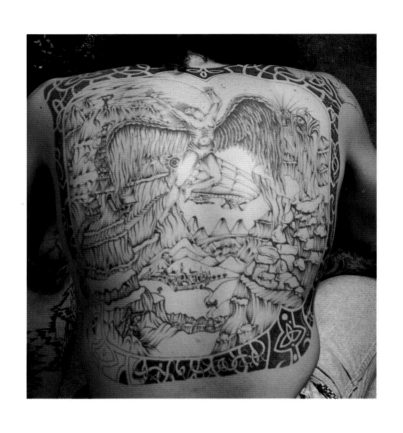

OPPOSITE *Vanessa (top), record executive, and Hooley, musician*

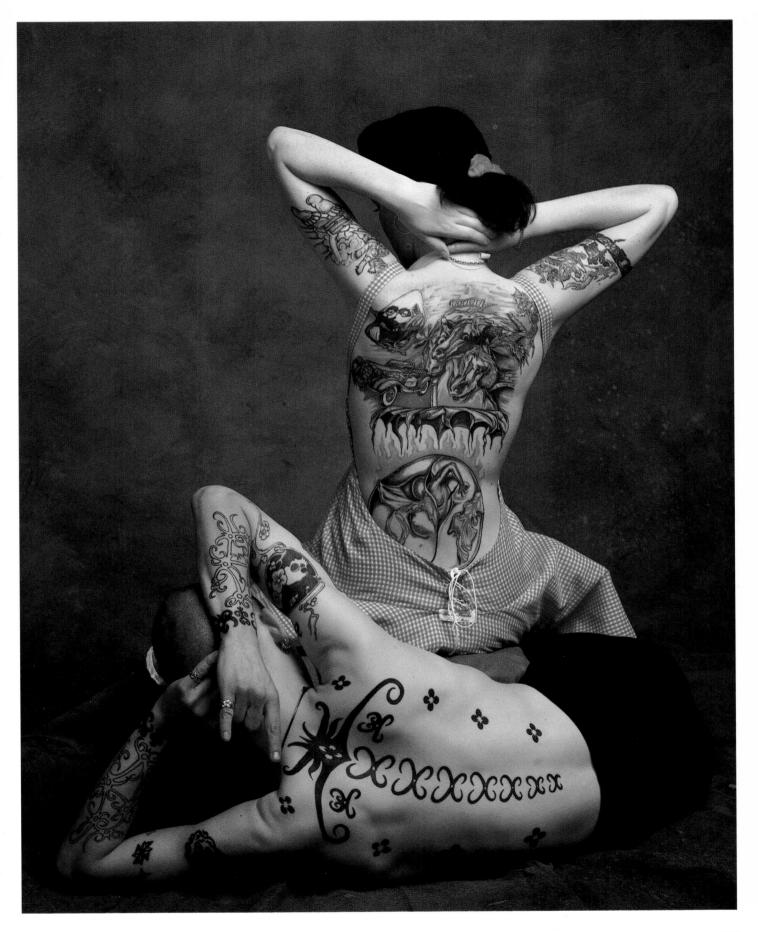

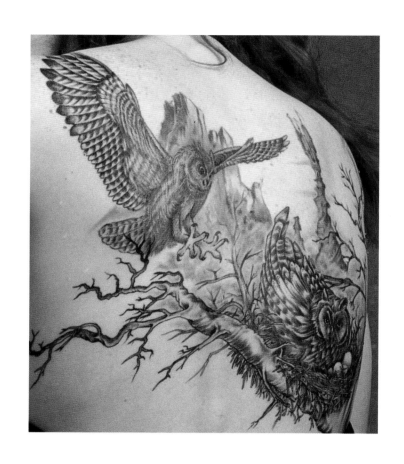

OPPOSITE *Kevin*

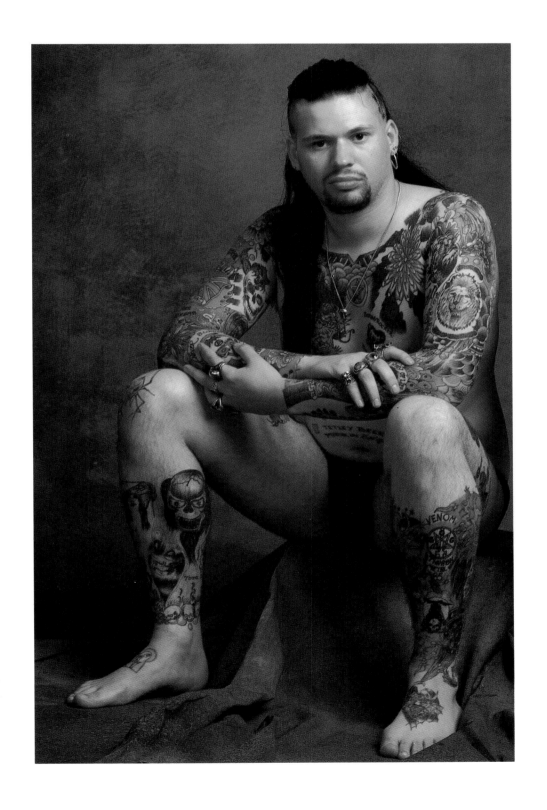

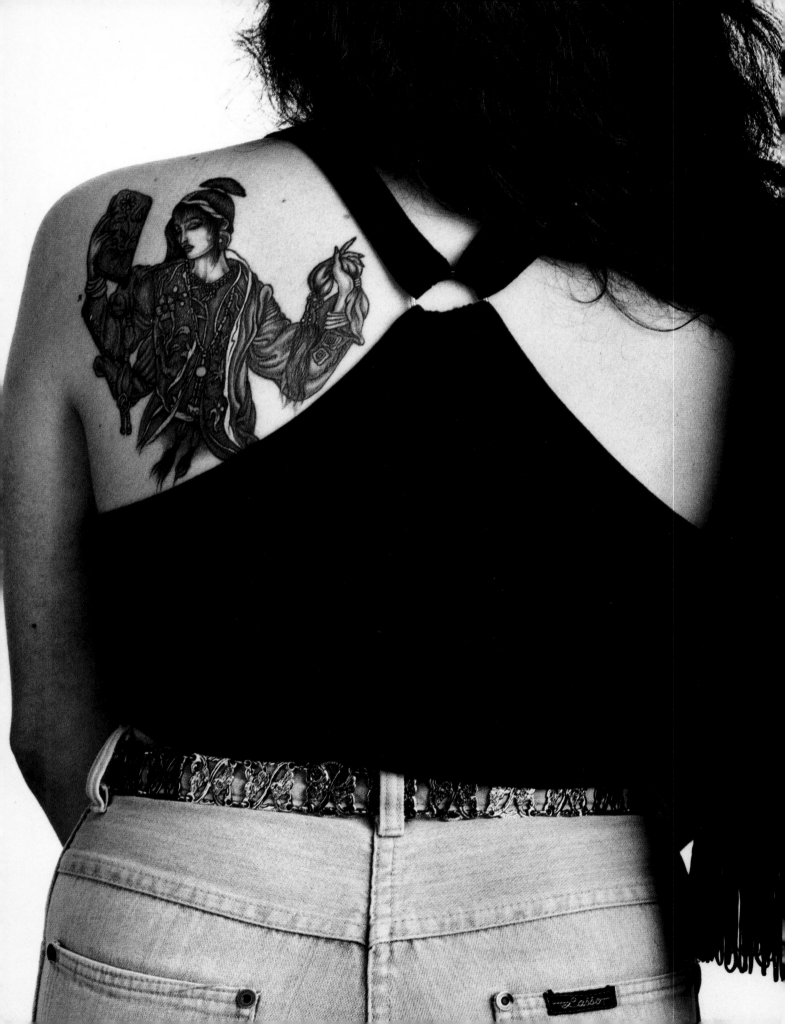

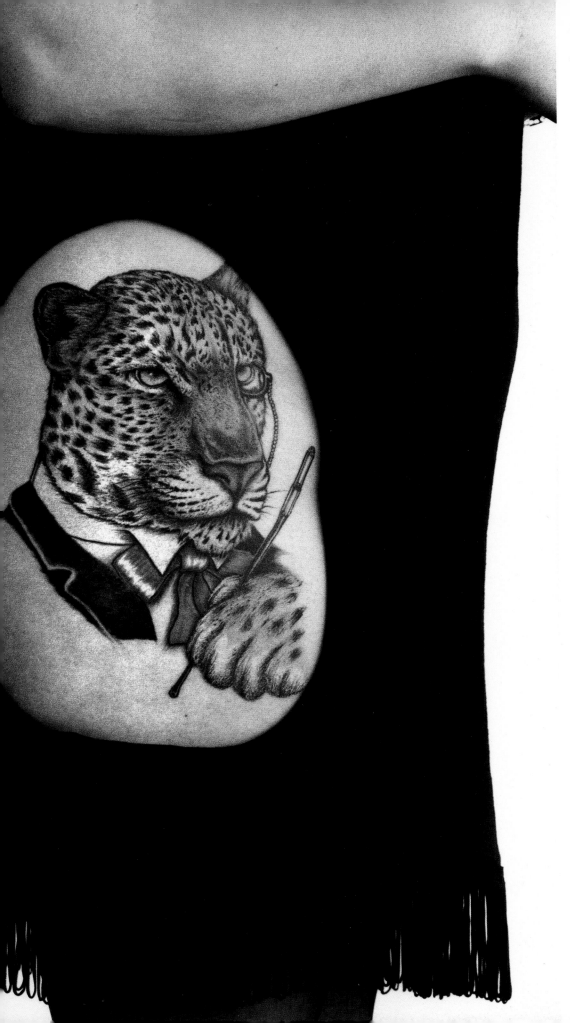

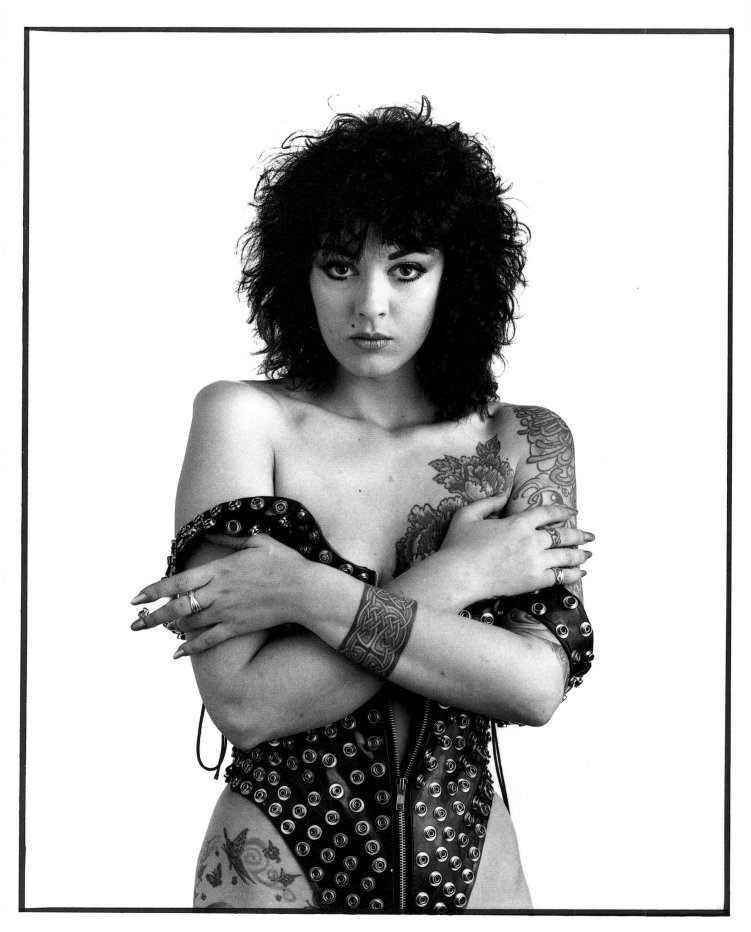

42

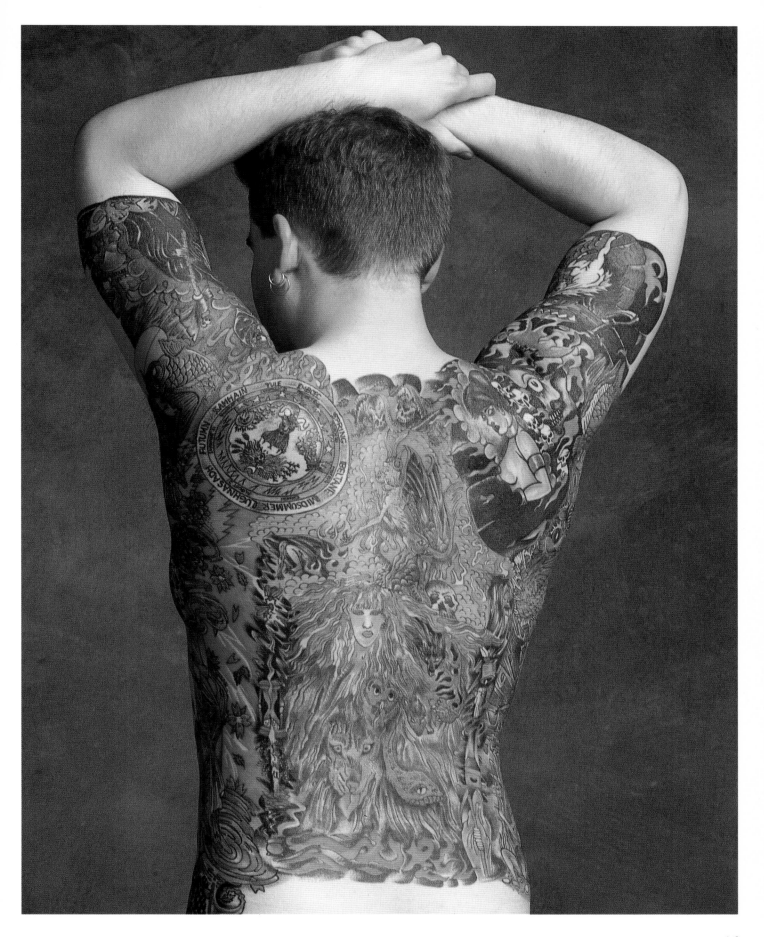

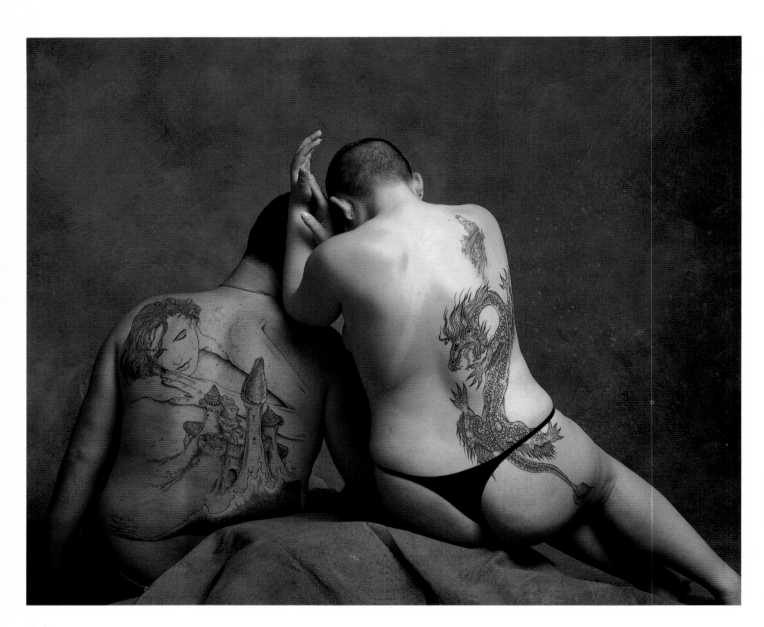

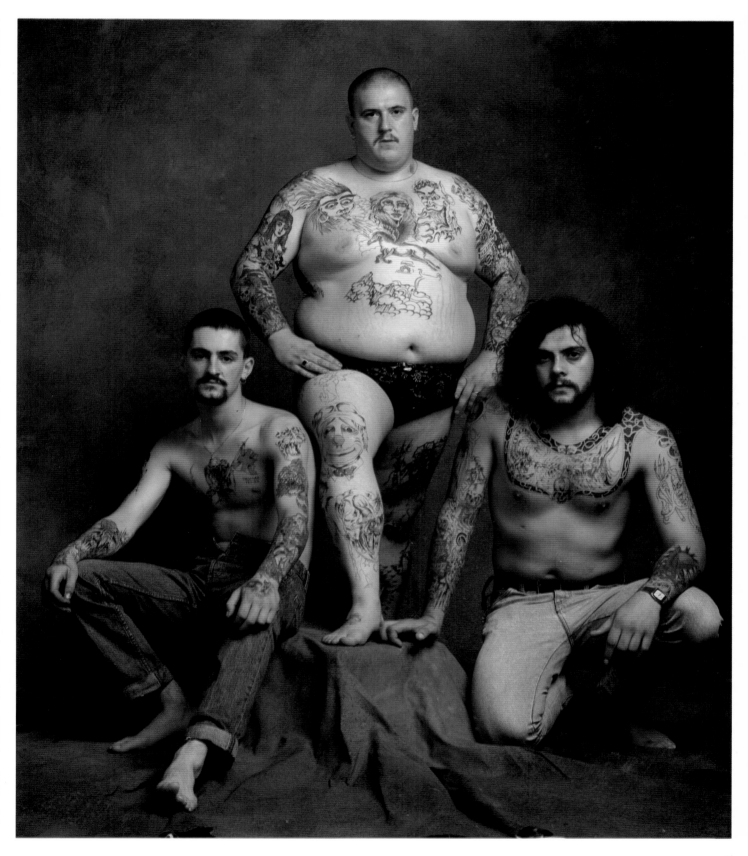

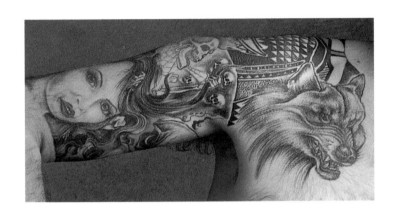

OPPOSITE *Tom*

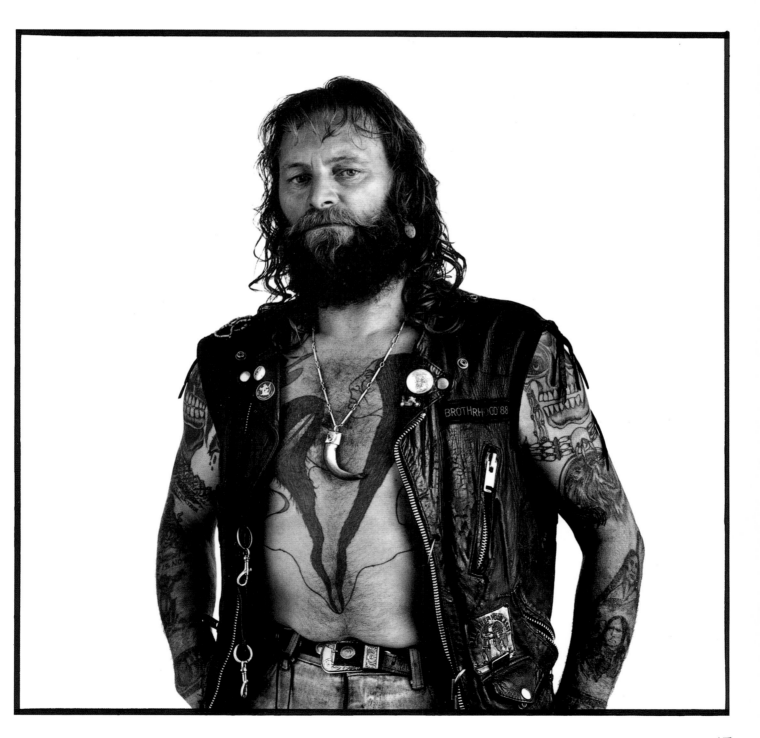

47

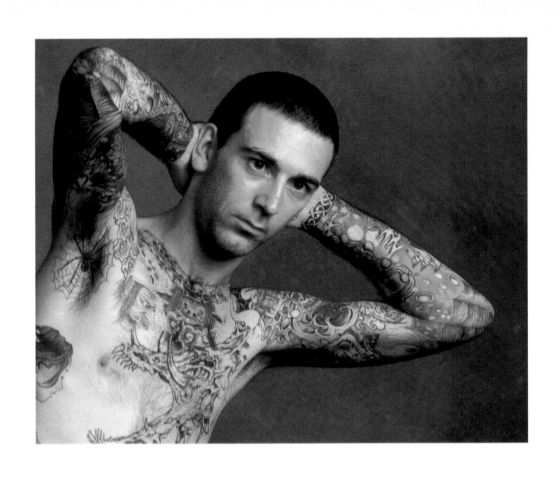

ABOVE *Nigel*
OPPOSITE *Lou, tattoo artist*

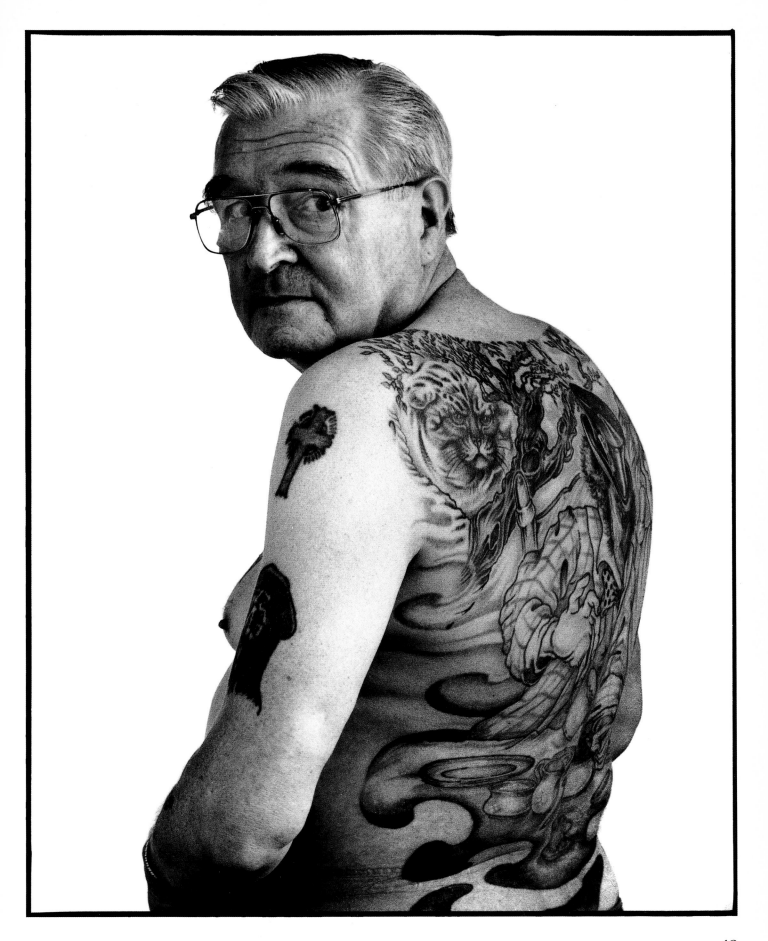

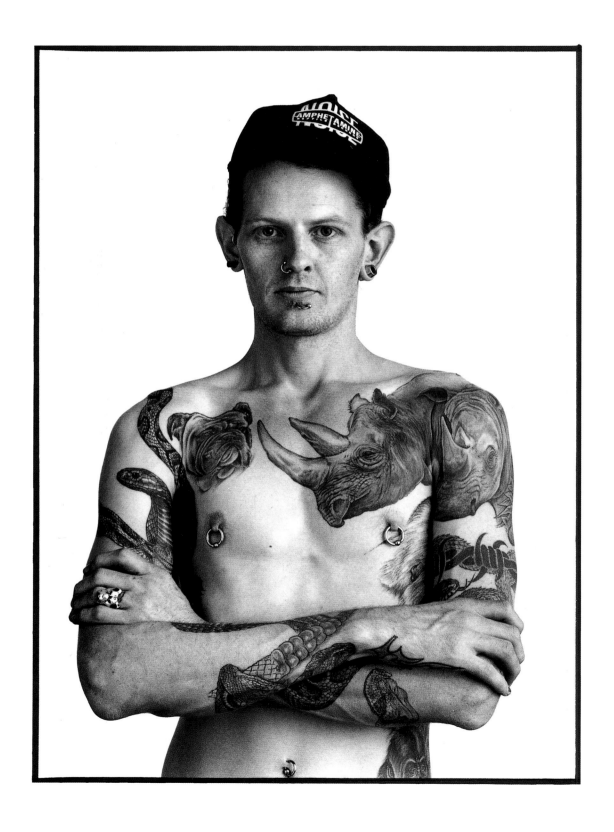

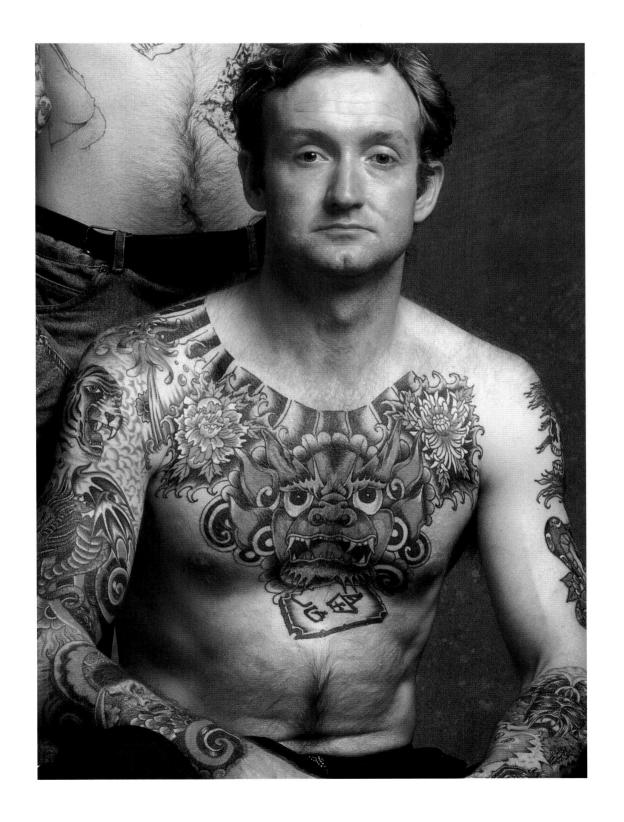

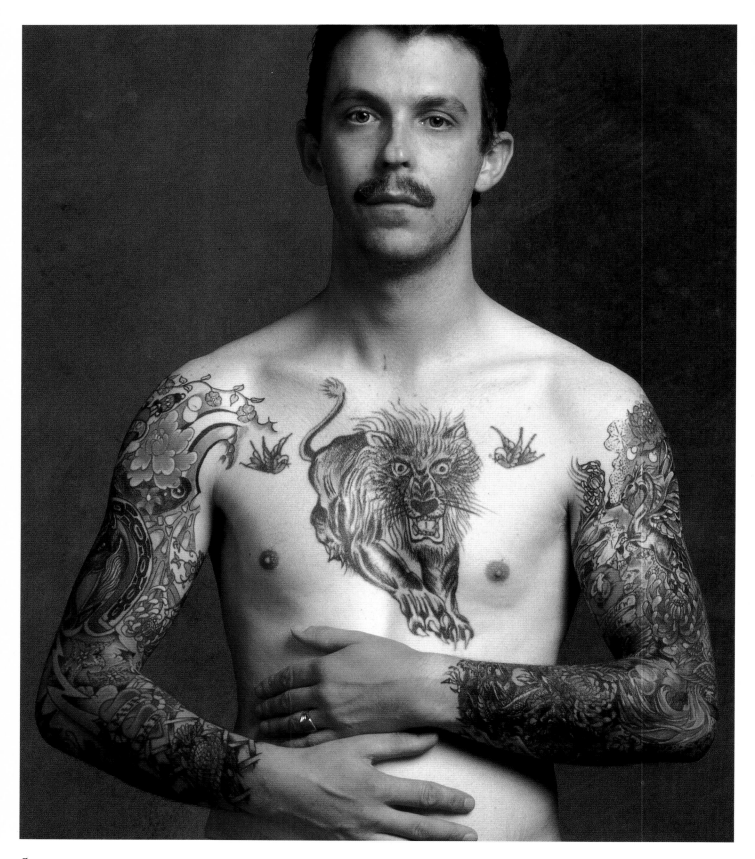

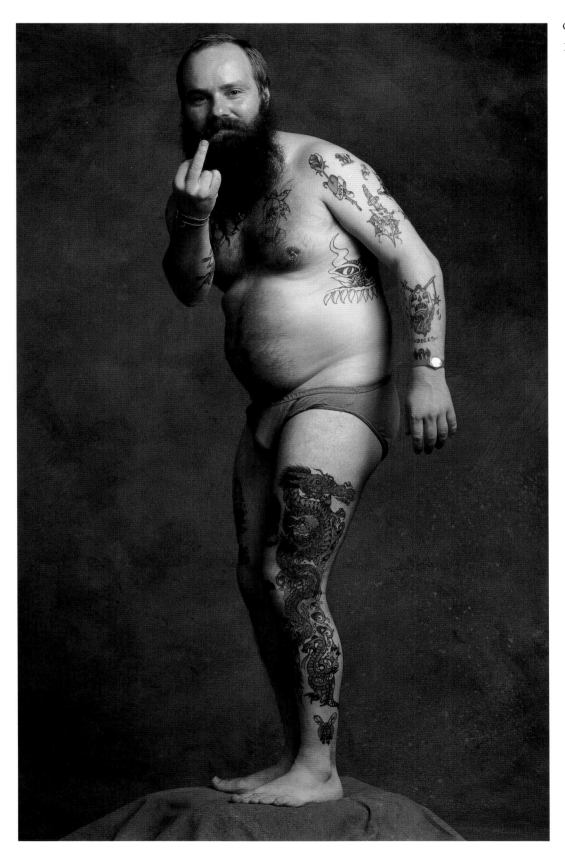

OPPOSITE *Eric*
LEFT *Les, ordained priest*

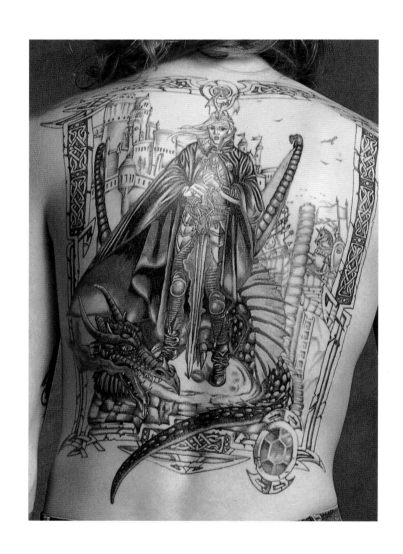

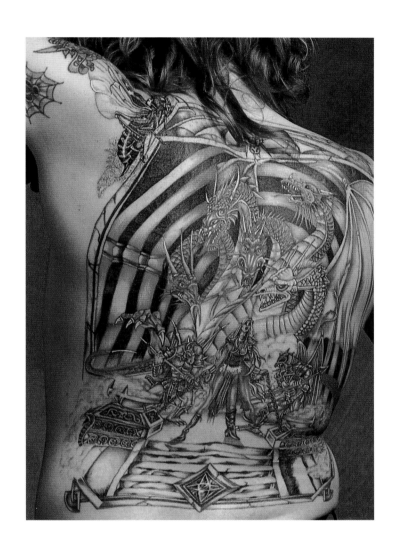

OVERLEAF *Stick, tree surgeon,*
Debbie, housewife, and Jim, rock singer

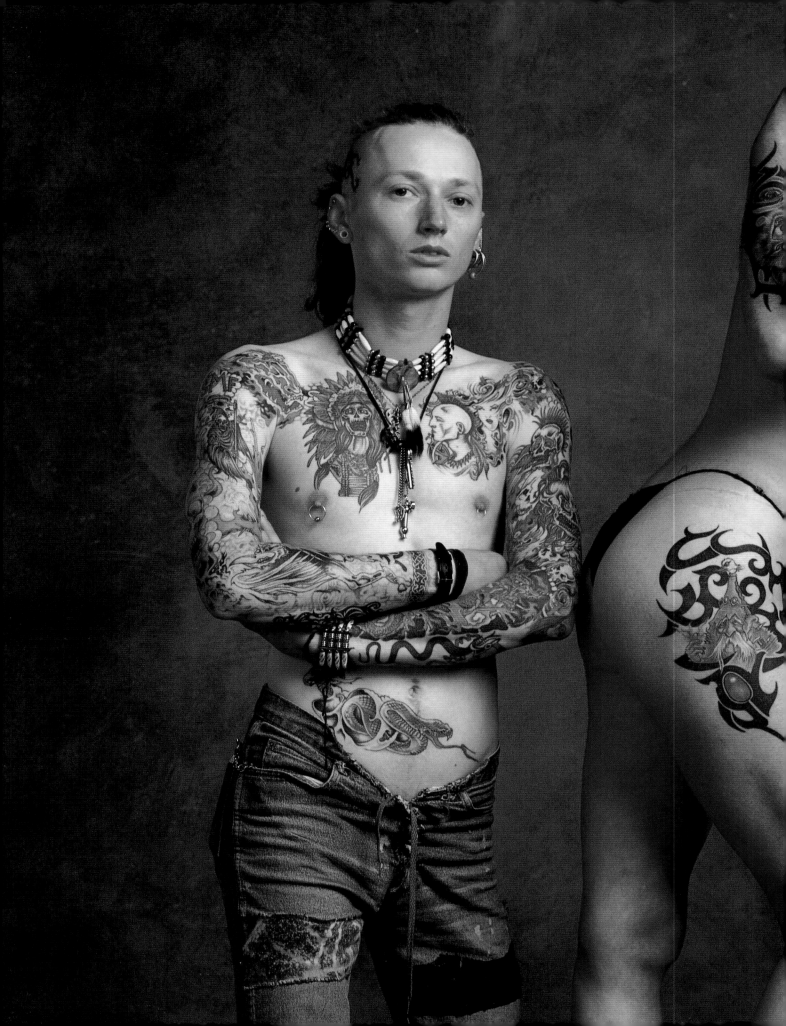

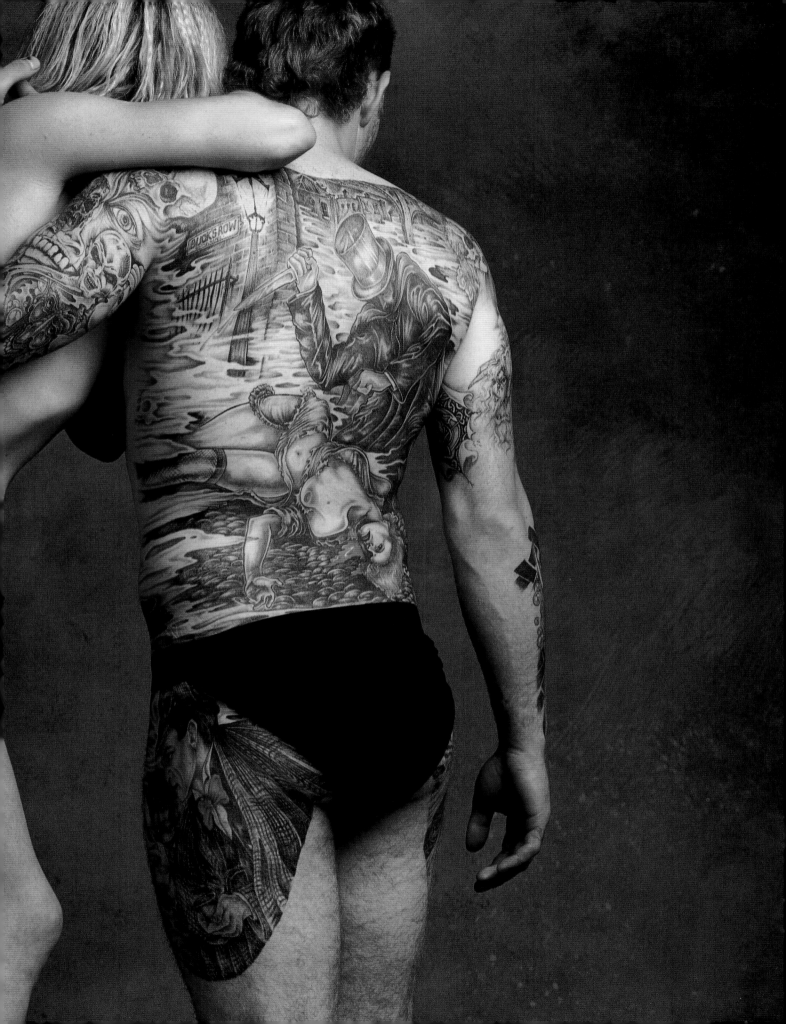

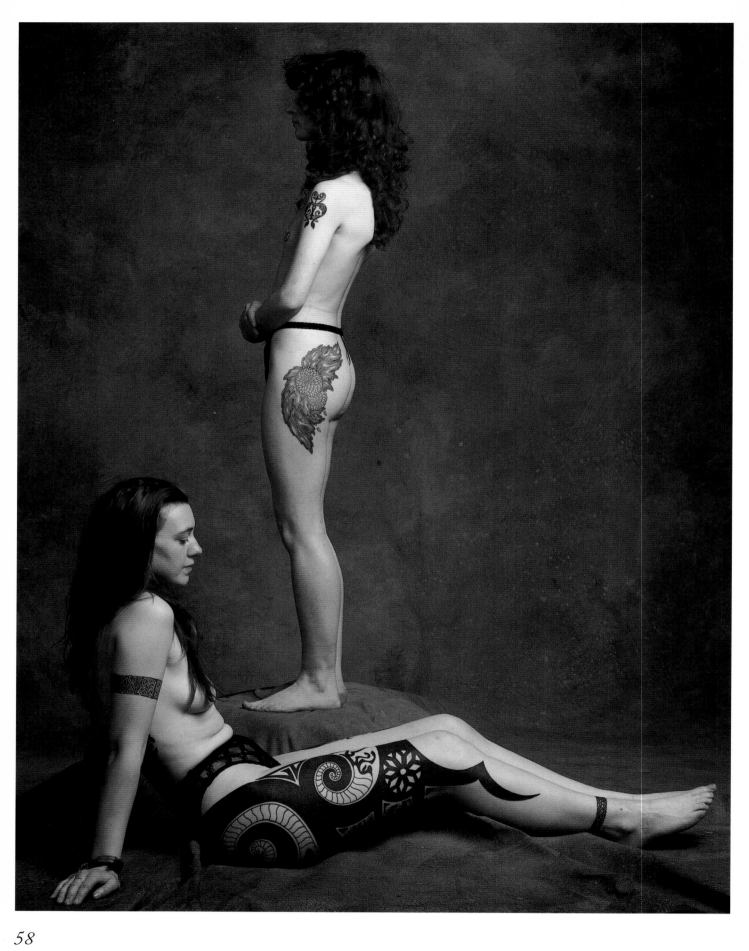

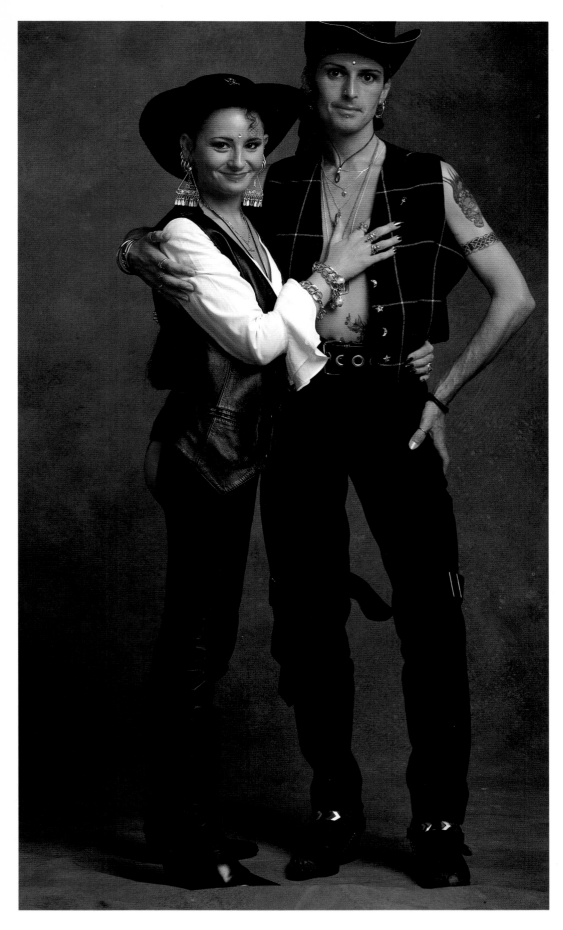

OPPOSITE *Lisa (standing), librarian, and Anne, writer*
LEFT *Margaret, retail manager, and Peter, manufacturer's agent*

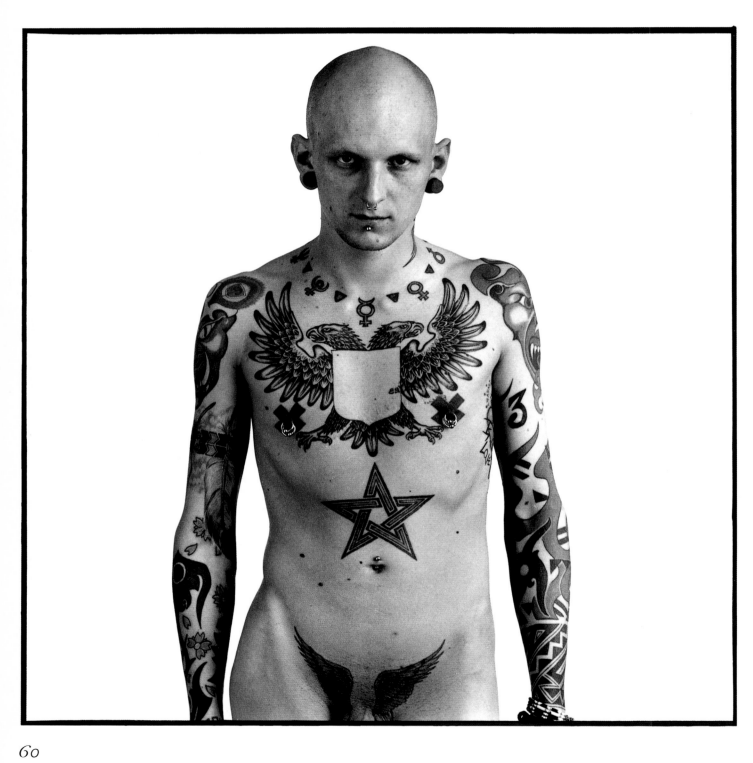

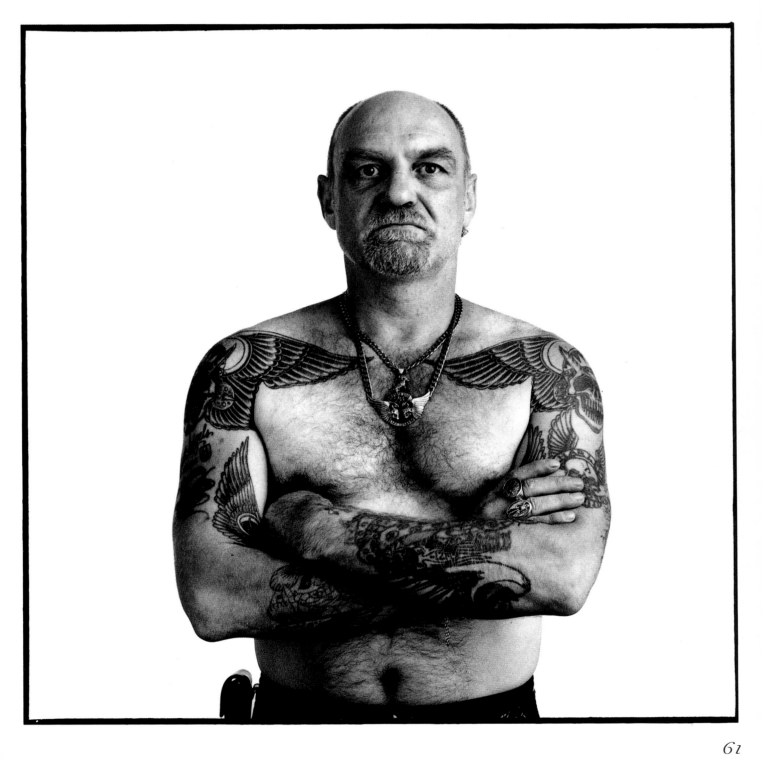

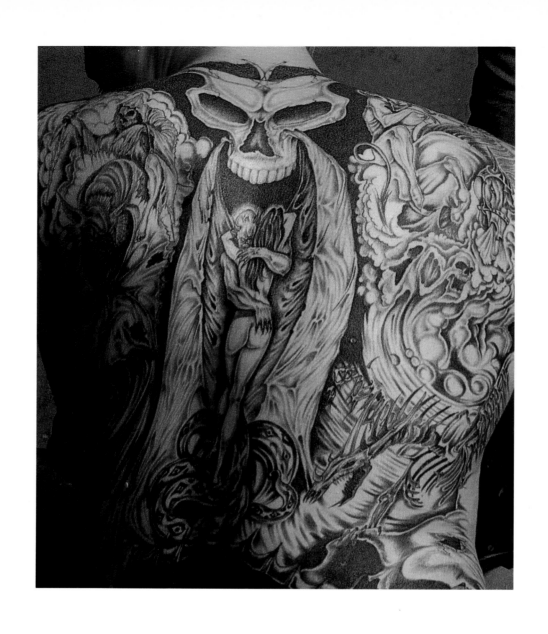

OPPOSITE *Jane, book-keeper, Phil (standing),*
plasterer, and Dave

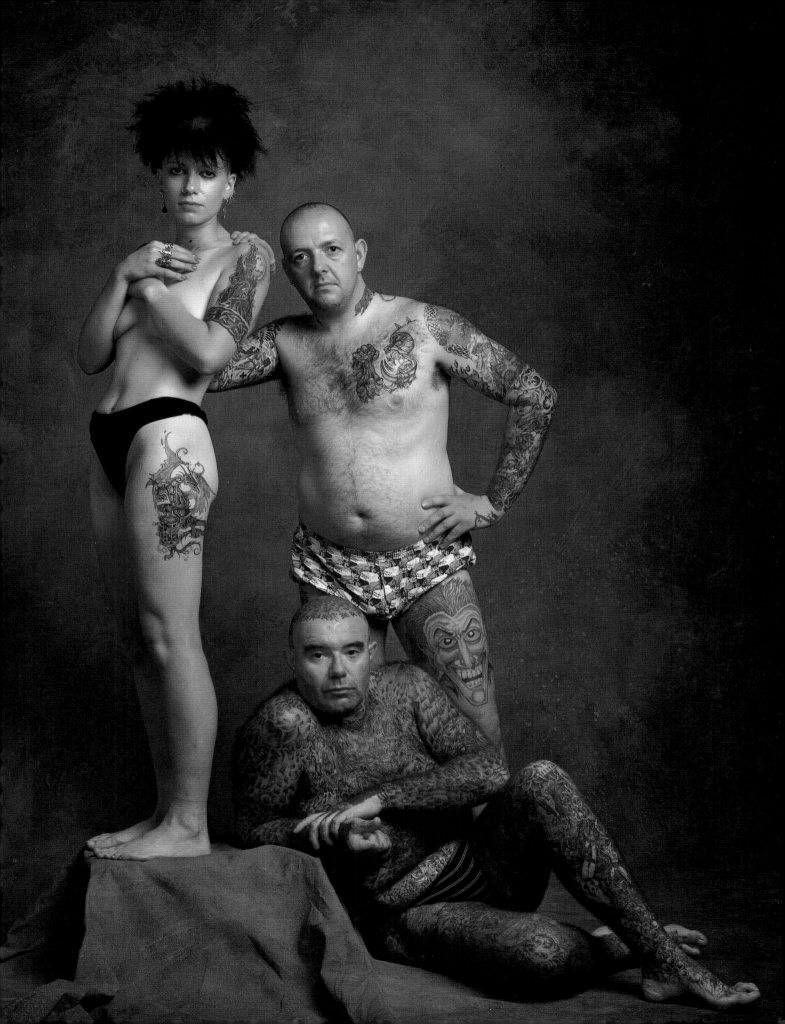

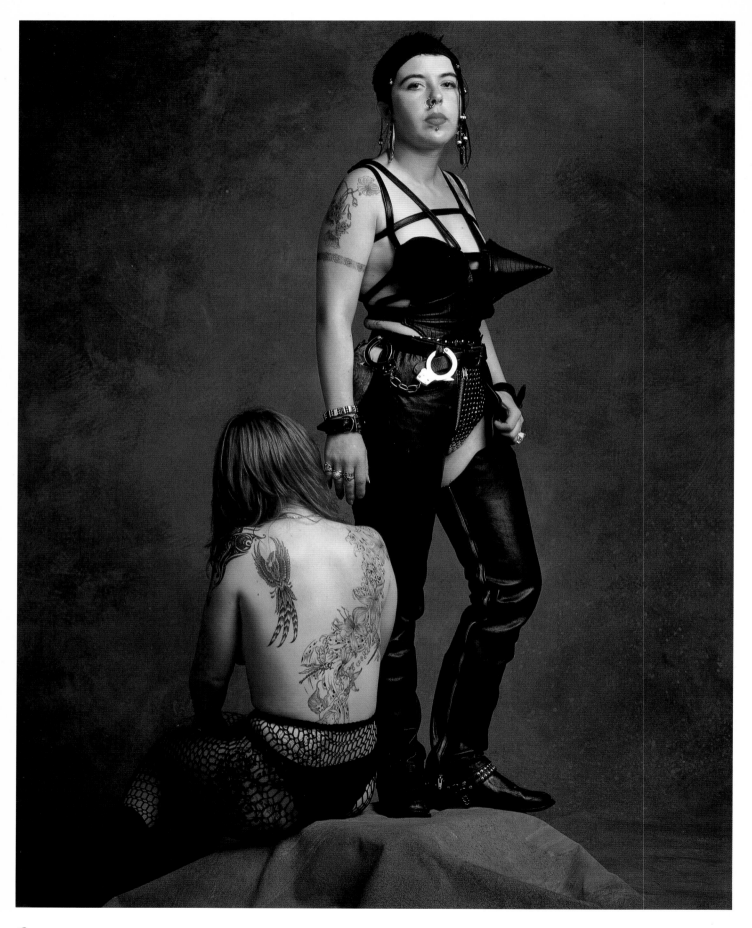

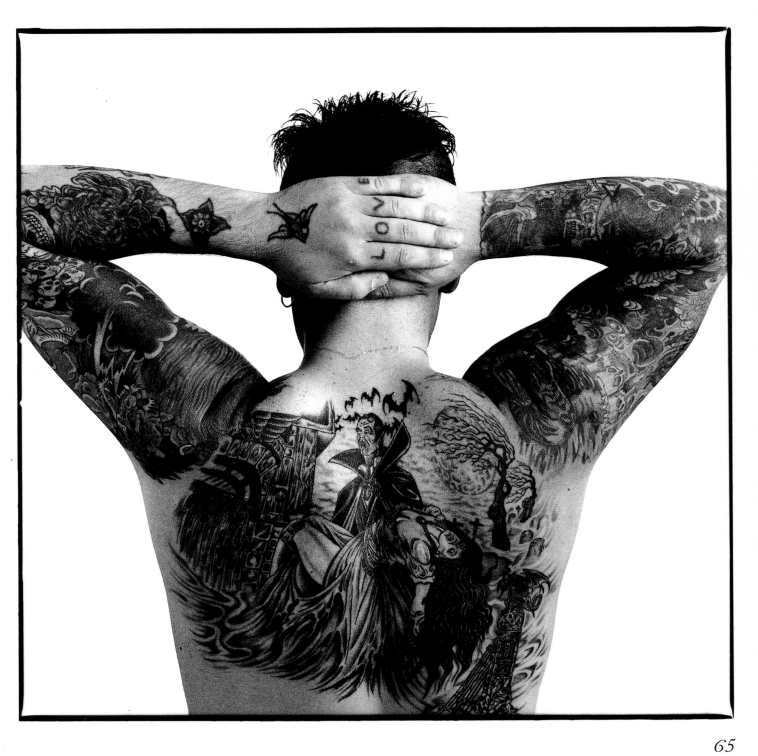

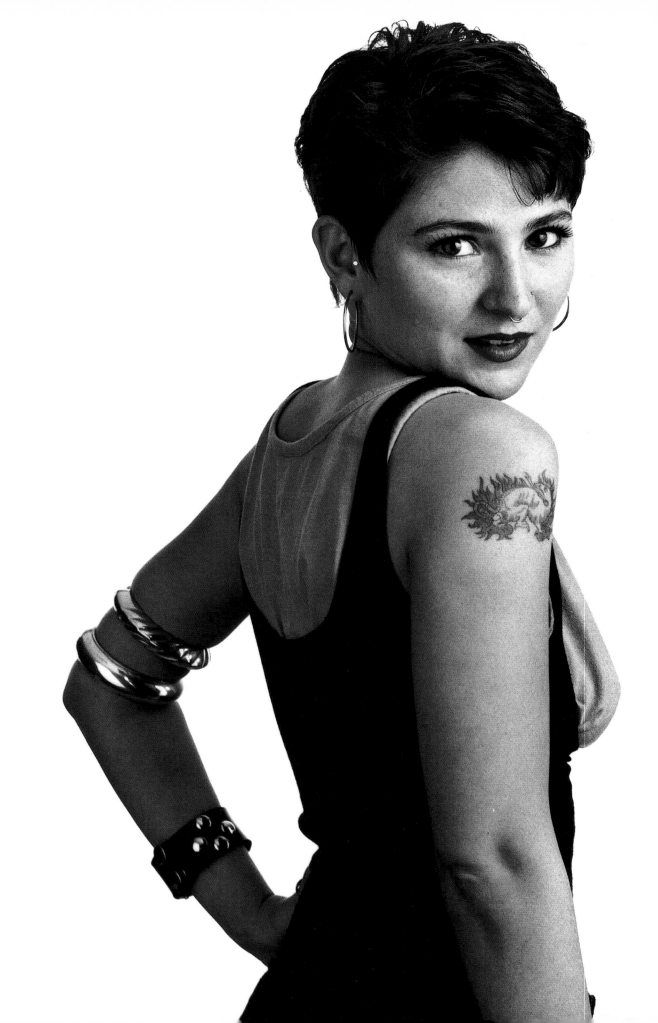

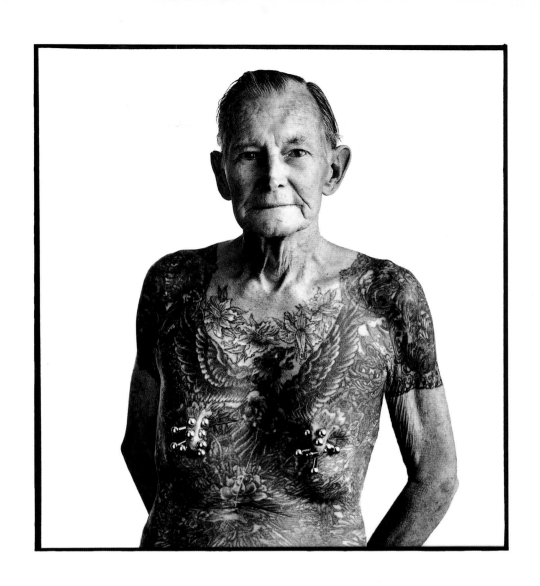

LEFT *Leila*
ABOVE *Mervin, retired*

BELOW *Mark, gardener, and David, scaffolder*
OPPOSITE *Lisa, librarian*

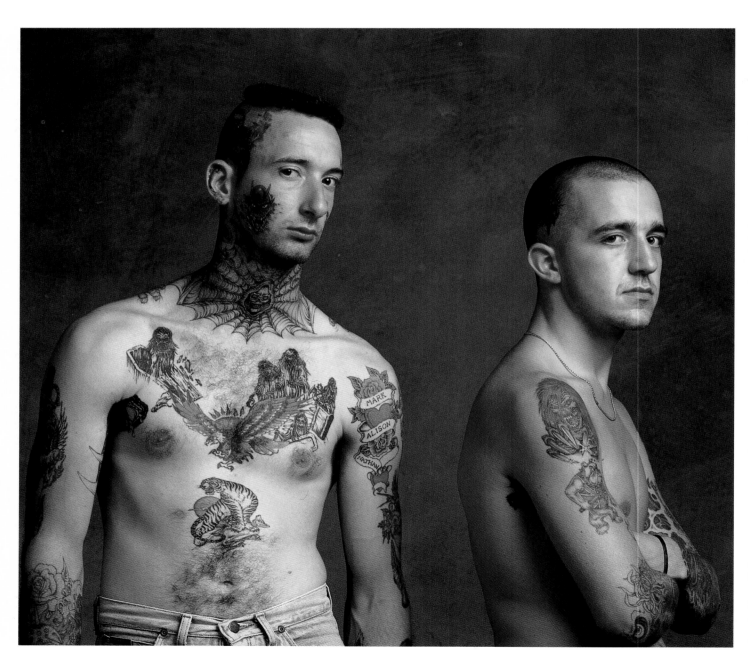

68

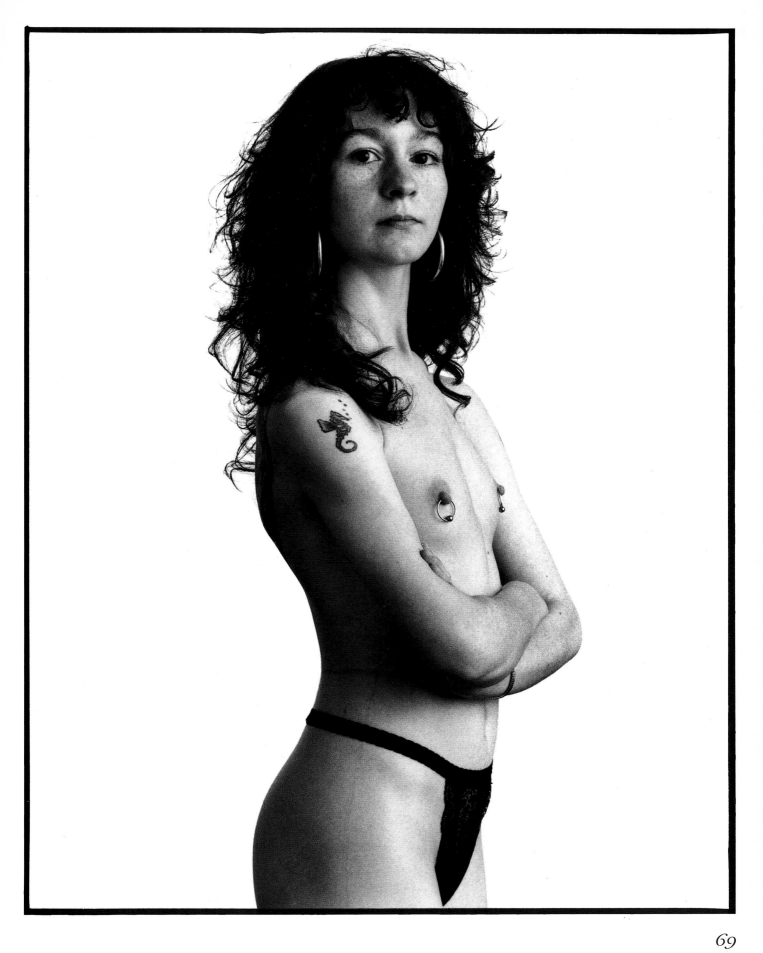

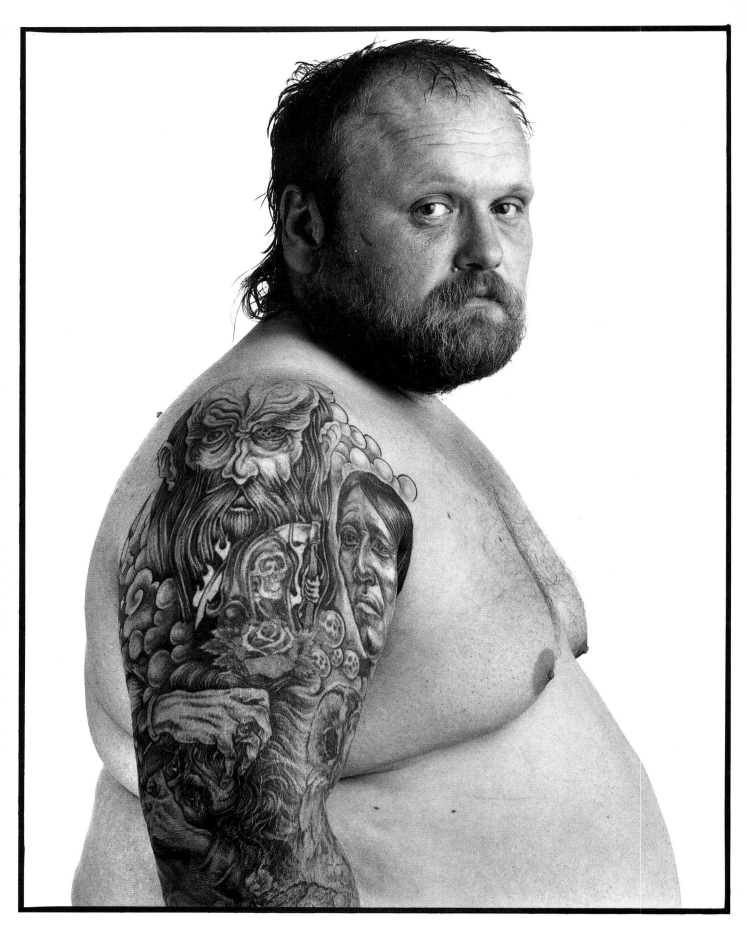

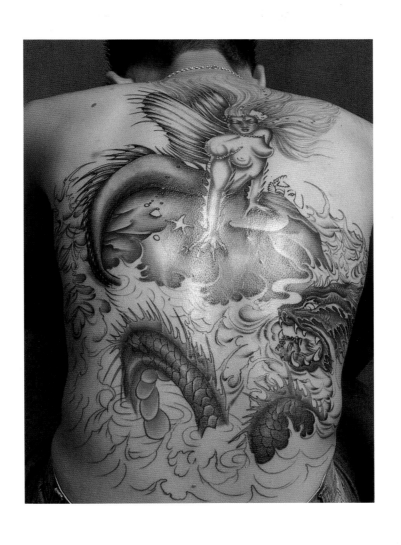

OPPOSITE *Robin, trucker and DJ*
OVERLEAF *Lee, Caroline, seamstress, and*
Patrick, sales manager

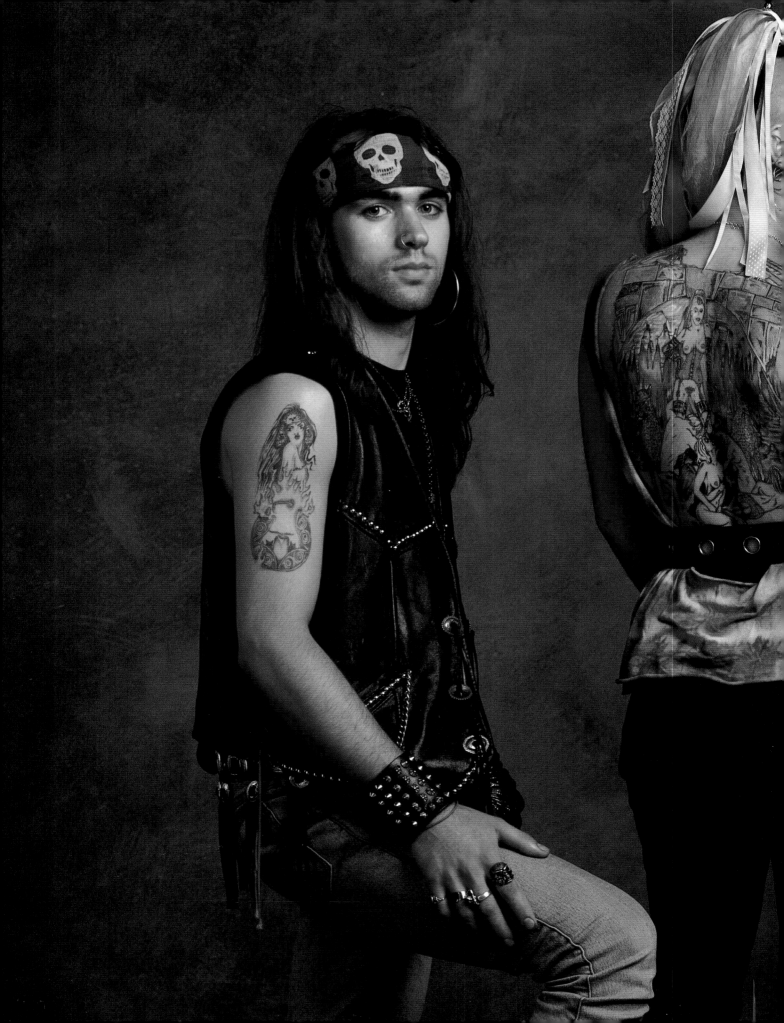

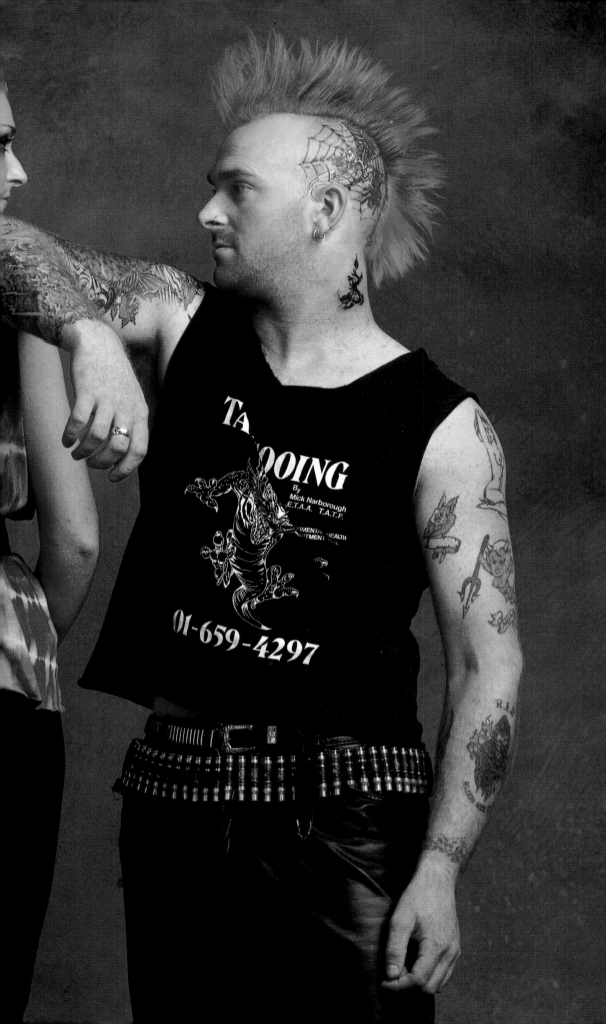

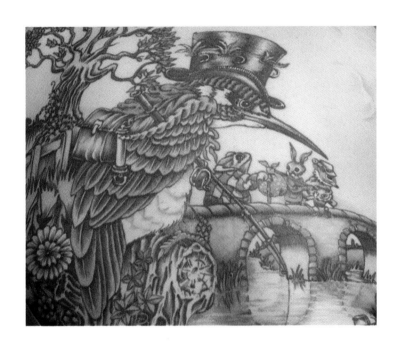

RIGHT *Tania*

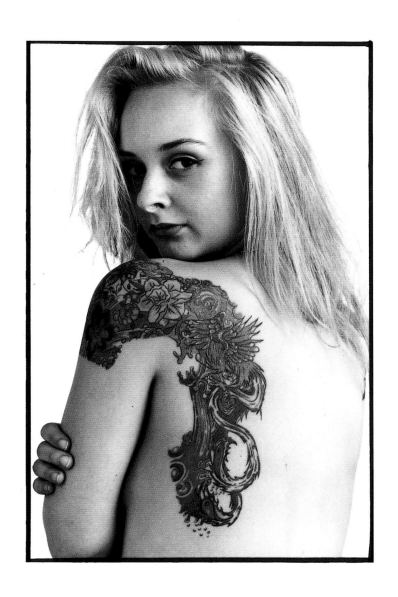

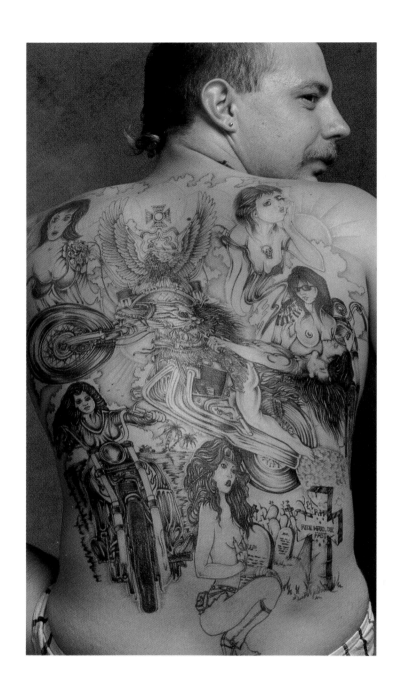

Peter

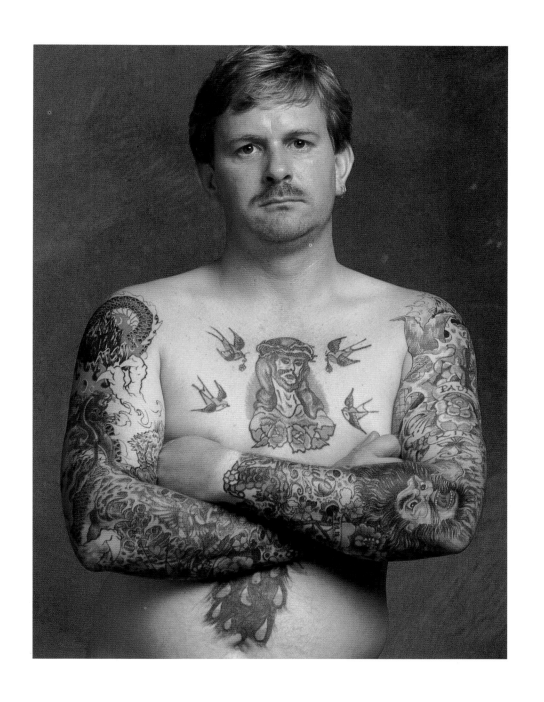

Paul

RIGHT *Tina, model
and kissogram*
OPPOSITE *Damian,
stage designer, and David,
psychotherapist*

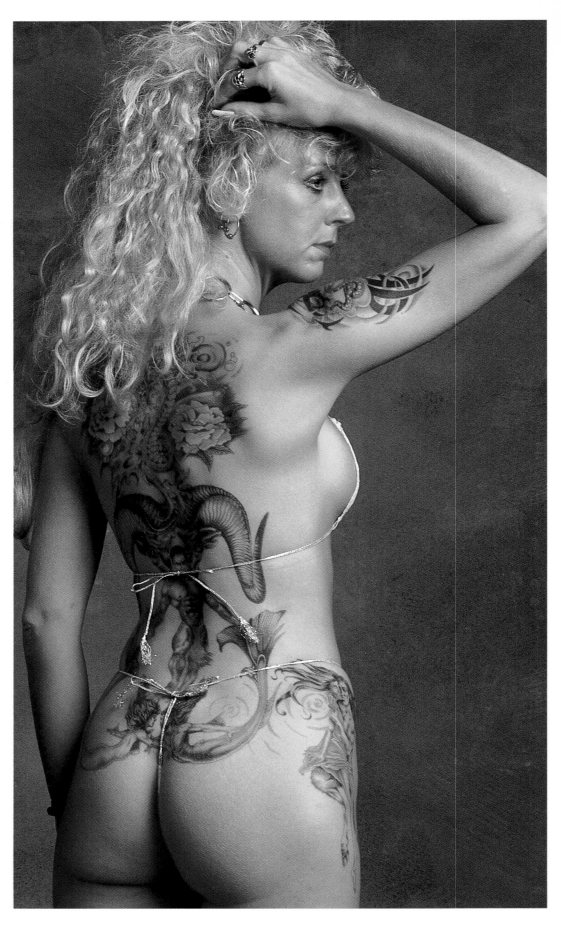

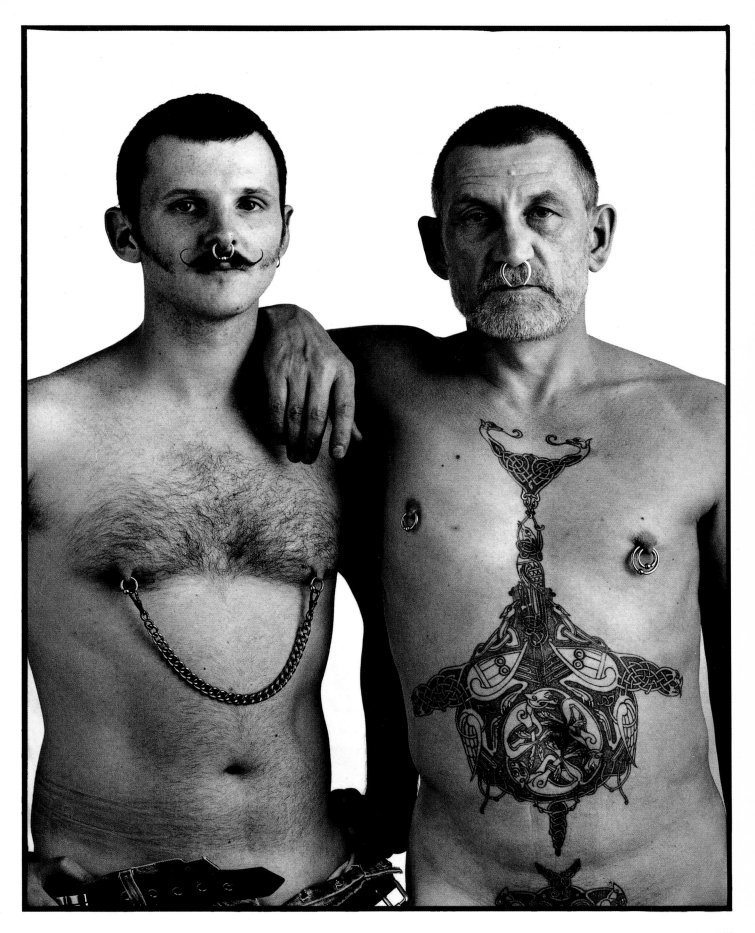

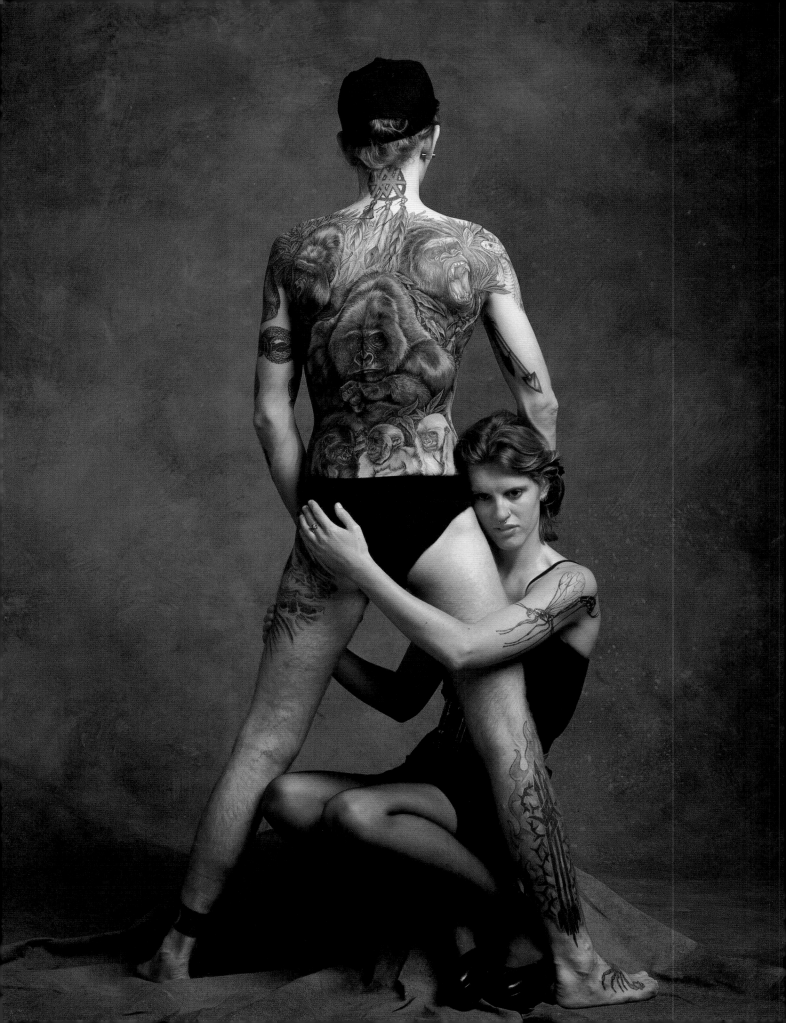

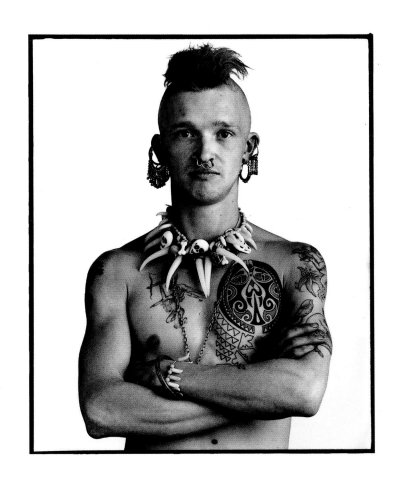

ABOVE *Gareth, body piercer*
OPPOSITE *Hamish, leather craftsman,*
and Tanya, nanny

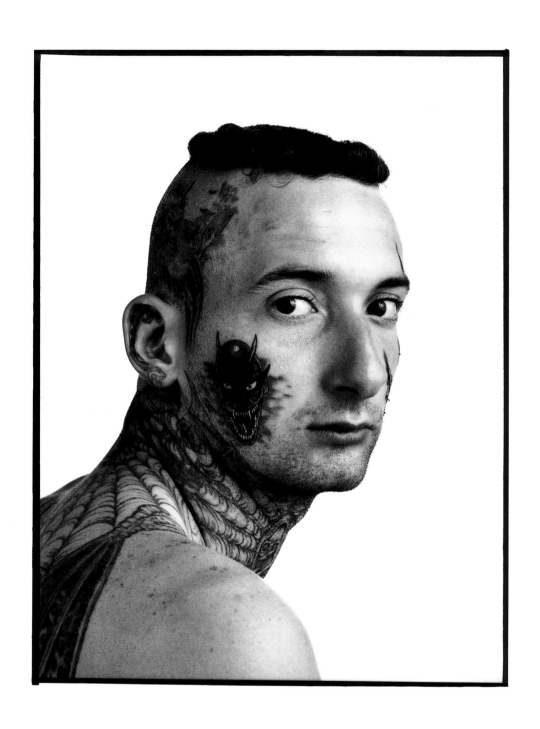

Mark, gardener

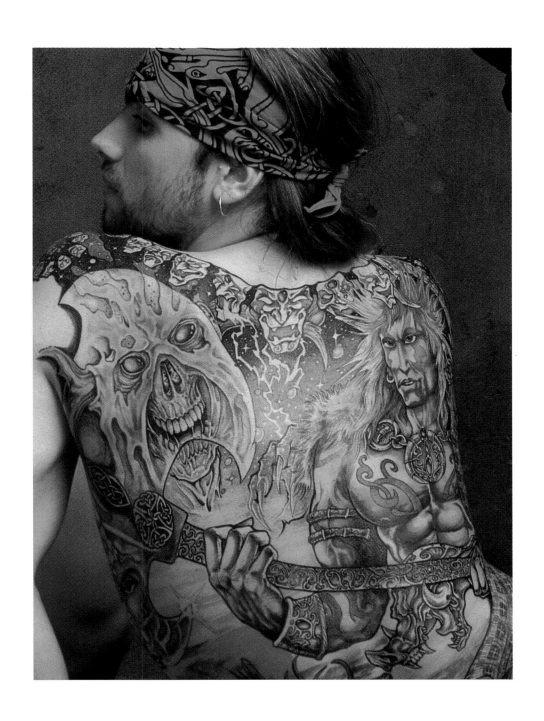

Dieter, apprentice tattoo artist

Claudia, Spike, chef, and Keith (with hat), engineer

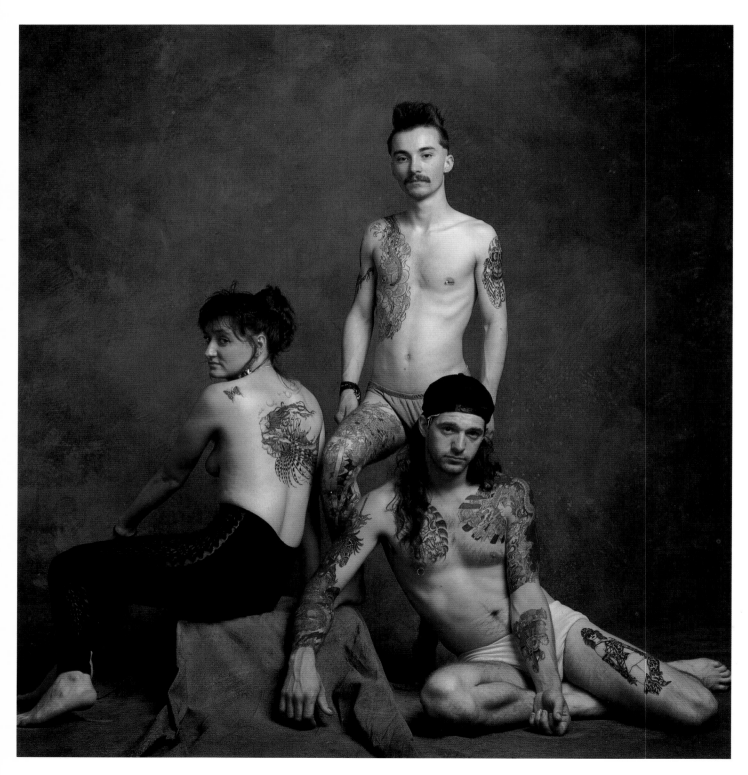

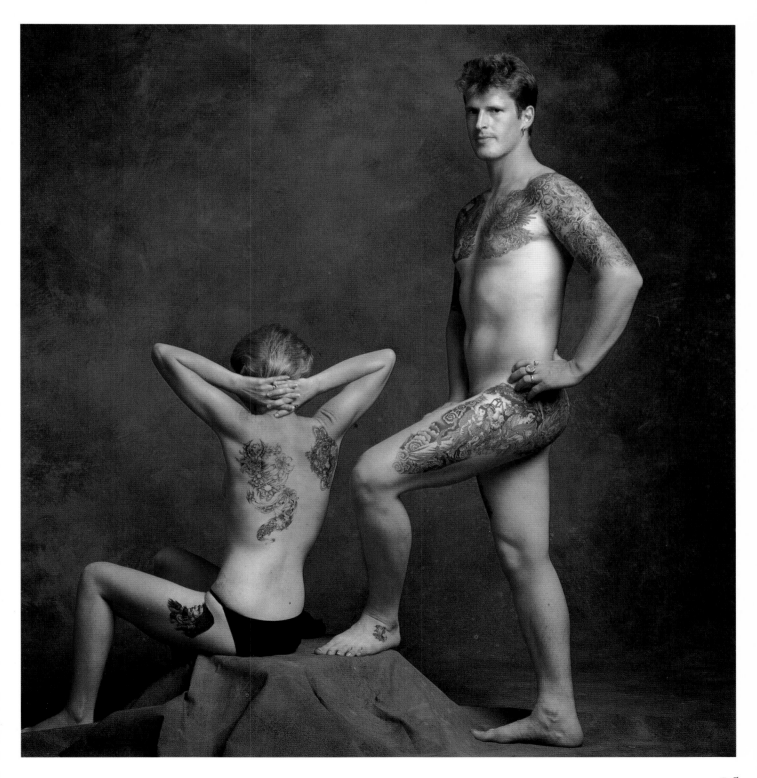

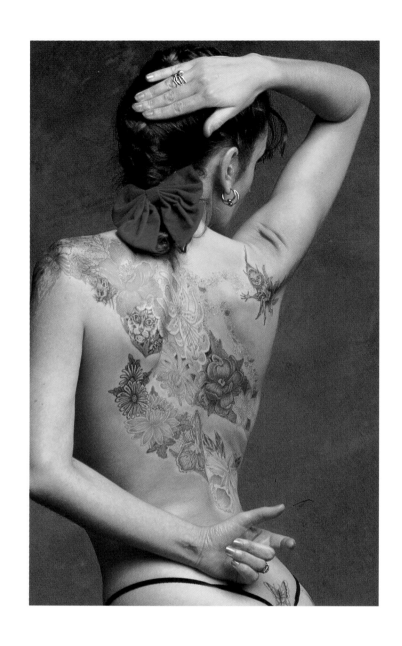

Karen, secretary

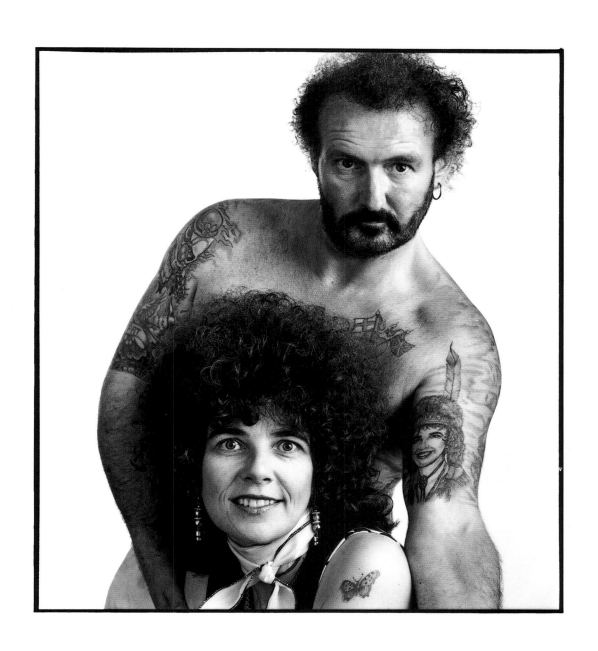

Tony, airport worker, and Pat, barmaid

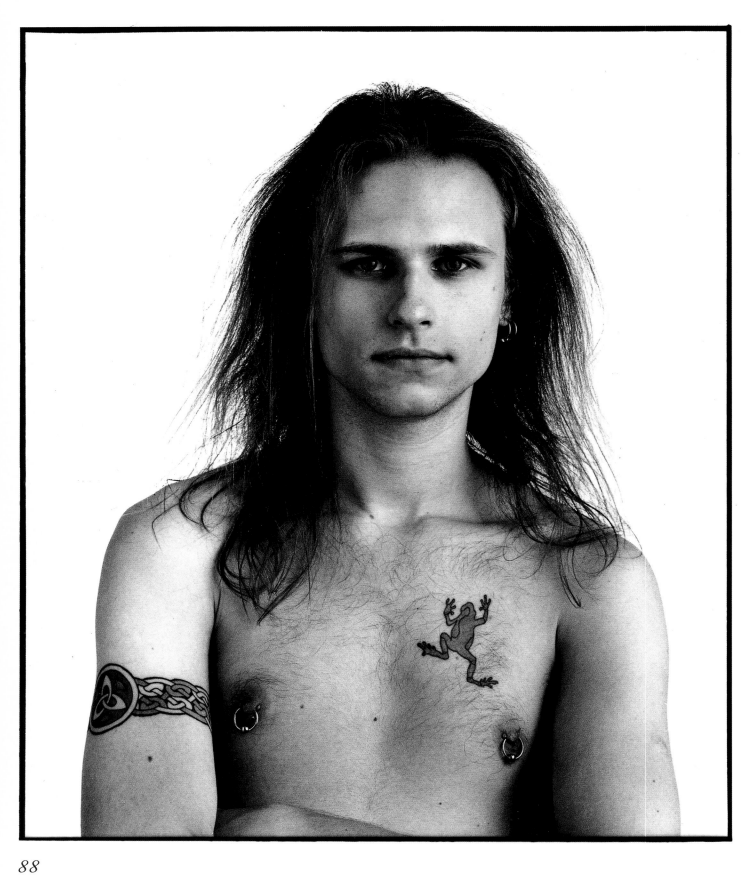

Goat, tattoo artist, Karen, and Snob, bike dealer

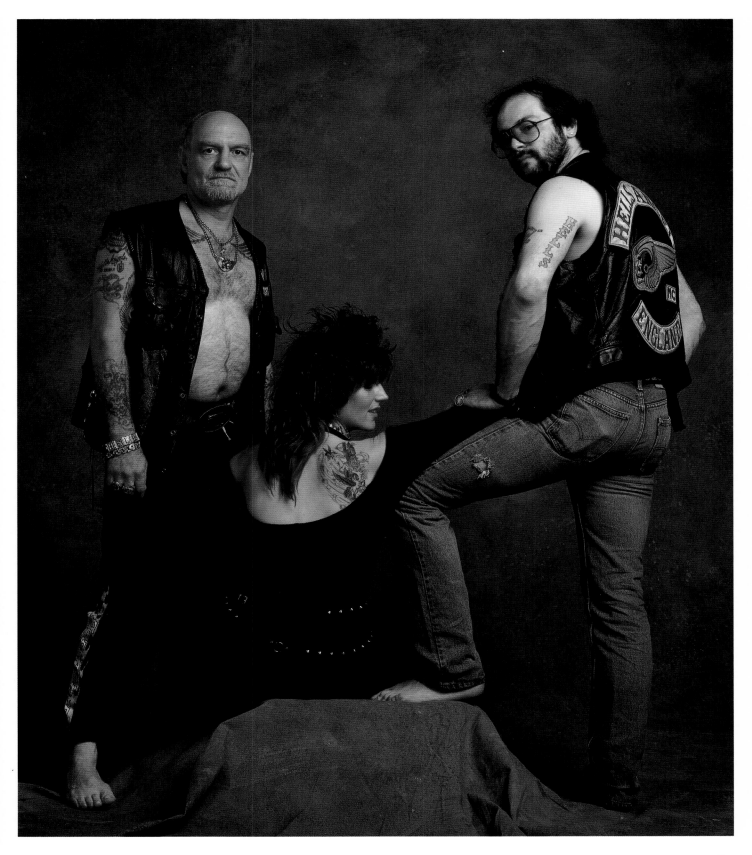

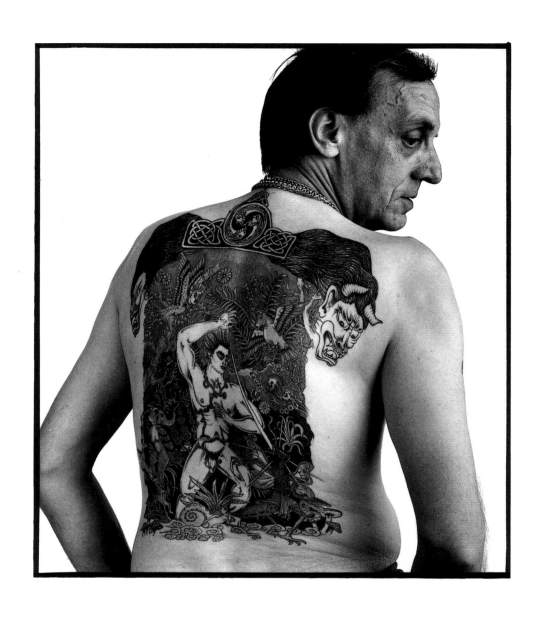

ABOVE *Mac*
OPPOSITE *Karl, Tony and Brian*

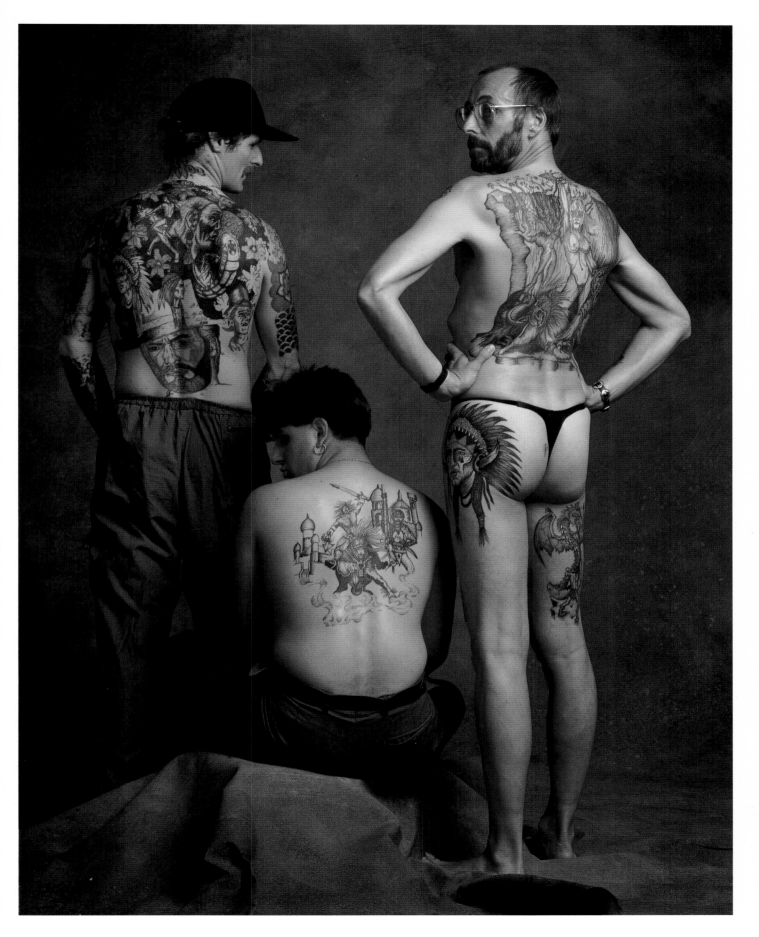

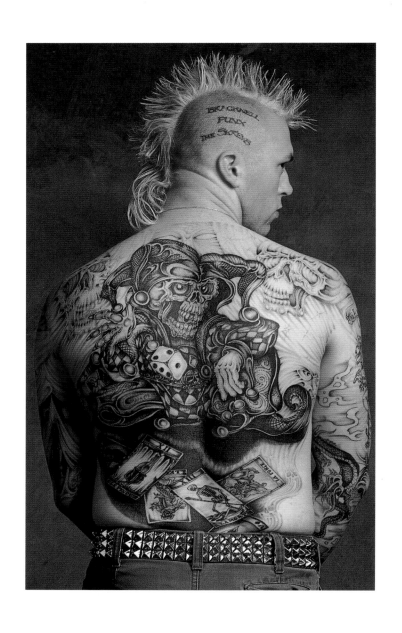

ABOVE *Gary, glass grinder*
OPPOSITE *Paul, preacher, Chris, engineer, and*
Martin, garden nursery owner

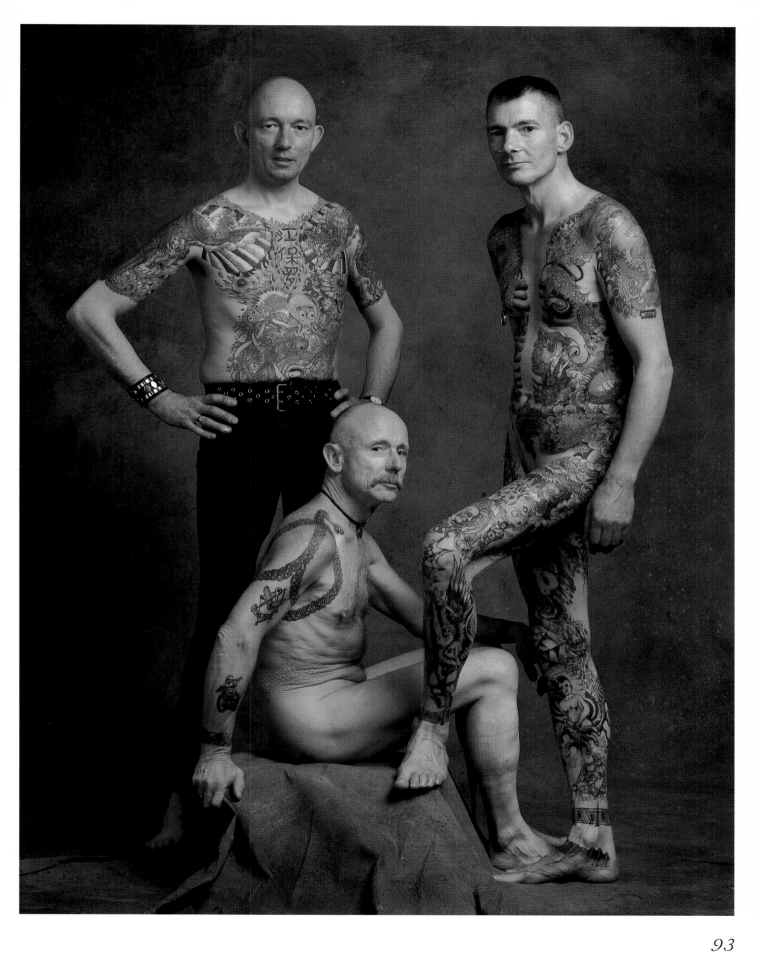

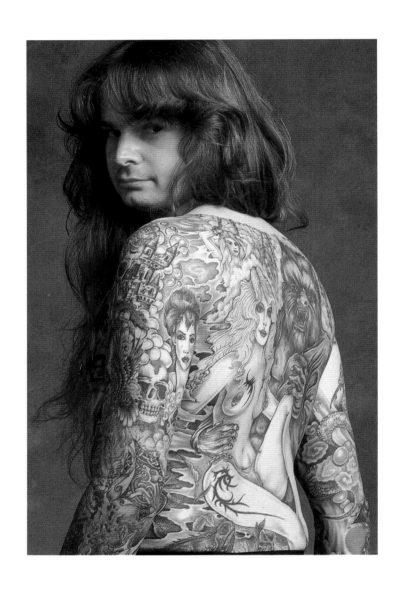

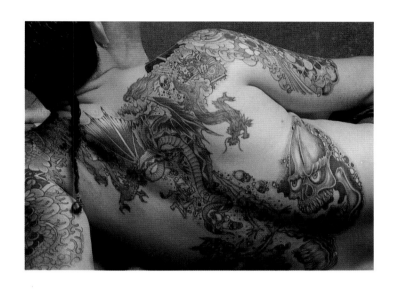

OPPOSITE *Mick, record shop assistant*

ACKNOWLEDGEMENTS

The photographer and publishers would like to thank the members of Tattoo Ink., John Williams, Ian Barfoot, Brent Eggleton and Lal Hardy, who organised the International Tattoo Expo 91, at the Queensway Hall, Dunstable, Bedfordshire, England, for making this book possible. We would also like to thank all the tattoo artists whose work appears in it. They are Boss Andersson, Brian Angel, Kevin Angell, Andy Barber, Phil Barry, Keith Bickle, Alex Binnie, George Bone, Brent, Bugs of Camden, Derek Campbell, Paul Cardine, John Capon, Tony Clifton, Dennis Cockell, Alan Dean, Rob Doubtfire, Yann Erkelens, Fritz, Ian Frost, Joe Graham, Claus Fuhrmann, 'Hanky Panky', Lal Hardy, Kevin Heath, Dave James, Andy Jay, Pete Larkin, Mark Lee, Lisa 'Art in the Skin', Fiona Long, Berni Luther, Paul O'Connor, Louis Molloy, Mick Narborough, Terry Oldham, Mark Pettigrew, Dave Phillips, Harry Potter, Steve Potton, Wally Poulton, Ian of Reading, Eric Reime, Ken Rivers, Bob Roberts, Loz Roberts, Barrie 'Saz' Saunders, Geordie Scott, Mr Sebastian, Micky Sharpz, Mark and Julie Sidgwick, Kevin Shercliff, Darren Stares, Pete Wilde, Dave Williams, Ziggy, and Leo Zulueta.

Finally, we would like to thank all the subjects of the photographs for appearing in the book.